IMAGES
of America

DOWNTOWN
NAPERVILLE

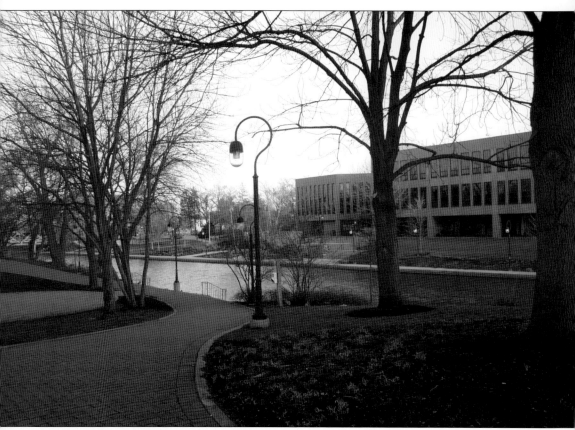

NAPERVILLE RIVERWALK. Centerpiece, jewel, treasure—it goes by many names, but the Riverwalk is undisputed in its position as an object of deep affection for most Napervillians. The 1981 sesquicentennial project has been credited with reviving downtown, helping to make it become what it is today. Seen here with a view of the Municipal Center (which opened here in 1991), the Riverwalk was originally built from the Main Street bridge west to the Eagle Street bridge, but now runs from Hillside Road to the Jefferson Street bridge (the Washington Street bridge to Hillside Road was dedicated in 2001).

On the cover: Please see page 46. (Courtesy of Kramer Photography.)

IMAGES of America

DOWNTOWN NAPERVILLE

Joni Hirsch Blackman

ARCADIA
PUBLISHING

Copyright © 2009 by Joni Hirsch Blackman
ISBN 978-0-7385-6062-5

Published by Arcadia Publishing
Charleston SC, Chicago IL, Portsmouth NH, San Francisco CA

Printed in the United States of America

Library of Congress Control Number: 2009924909

For all general information contact Arcadia Publishing at:
Telephone 843-853-2070
Fax 843-853-0044
E-mail sales@arcadiapublishing.com
For customer service and orders:
Toll-Free 1-888-313-2665

Visit us on the Internet at www.arcadiapublishing.com

*To Ryan, Jake, and Beth, who I loved watching grow up
in Naperville, and to Marc—whose Naperville childhood
brought us here—for being willing to stay.*

CONTENTS

Acknowledgments		6
Introduction		7
1.	An Overview of Naperville, Literally	11
2.	The Shops of Jefferson Avenue	21
3.	Washington Street, Where it Began	53
4.	Up-and-Coming Van Buren Avenue	85
5.	Not Really the Main Street	91
6.	That Odd, Short, One-Way Jackson Avenue	109
7.	Chicago Avenue, or Water Street	117

Acknowledgments

I would first like to thank the people who have spent their lives in Naperville who opened their homes and their photo albums and described the Naperville of their youth to the newcomer who asked. They include Steve Rubin and Norm Rubin who put up with my telephone calls and e-mails, the late Joe Rubin who introduced us years ago, and Norm's assistant Catherine Weinberger; Rita Fredenhagen Harvard and her efforts to track down Prince Castle photographs; Bev Patterson Frier and her lovely hospitality and encouragement; Lana Heitmanek's gracious offerings of her Beidleman photographs; Tom Wehrli's always great advice; Mary Lou Wehrli's generous sharing of her resources (her photographs and her memories); Annette, Don, and Jean Wehrli's helpfulness when I needed trolley photographs and expert eyes; Andrew Siedelmann's patience and scanner; Steve Hyett's boxes of slides and fabulous stories; Ron Keller and his knowledge of Naperville history; Mary Givler and Jennifer Fraley and their kindness to a stranger on the telephone; Rick Motta and Stu Carstens for the same; Tom Klingbeil and his great photographs and conversation; Rose Barth and her enthusiasm and foresight to take pictures of Someplace Else and Leonardos; artist Marilyn Polivka and her hospitality and suggestions; Bill Anderson's lighting-speed computer and photographs from his parents' attic; Liza and Clyde C. (Clay) Netzley III for their diligence in finding me some great photographs of their father's business; Chuck Seidel's steadfast support any time I have ever asked about anything, especially the carillon; Buzz Nelson for lending me a beautiful collage of photographs; Ken Patel for finding a photograph of Wilma's; Jerry Goldstone for taking and sharing a photograph of Miller house before he tore it down; and a special mention of Lee Sack, who owned a car dealership in Naperville for just five years around 1960, but at the age of 87 and from faraway Tucson, Arizona, remembers every single place and name of those years before arthritis drove him from the town he so enjoyed.

I also must thank the kindness and efficiency of Donna Sack of Naper Settlement, who encouraged me when this project was just a thought; Bryan Ogg and Louise Howard at Naper Settlement; Brandy Fanter at Charles Vincent George; Katie Wood at the Downtown Naperville Alliance; Neil Gates of Neil Gates Photography; Melea Smith at District 203; Keith Hartenberger of Edward Hospital; and librarians Laurie Kagann and Trish Hard of the *Naperville Sun*, who put up with my persistent calls and e-mails.

Of course, I cannot forget Jeff Ruetsche of Arcadia Publishing who somehow got me into all of this—a project that turned into much more than I anticipated but with many unexpected rewards.

—Joni Hirsch Blackman

INTRODUCTION

When 23-year-old Joe Naper arrived from Ohio by way of a three-day wagon trip out of Fort Dearborn (Chicago) in 1831, he set about building a town. The streets he laid out in 1842 are no different than those Napervillians know now. In fact, many of the buildings Naper saw built are still home to thriving businesses in Naperville's downtown today.

The Historical Encyclopedia of Illinois describes Naperville like this: "Naperville's location, twenty-eight miles from Chicago and surrounded by a rich country, makes it a good business center. There are in 1912 four general stores, seven grocery stores, three hardware stores, three drug stores, five confectionery stores, two bakeries, two banks, three milliner stores, one feed store, three plumbing and supply houses, four blacksmith shops, two wagon shops, two furniture stores, two tobacco stores, five barber shops, three livery stables and one garage."

Obviously, downtown has changed a bit since 1912. Old-timers will say that downtown is not the same place they once knew. It is not the same place that when a fire truck was dispatched from the downtown station, Frank Lisjake would run outside of his Soukups Hardware store and stop traffic on Washington Street so the truck could get through.

Some are sad about that; some figure things change and shrug their shoulders. On the other hand, many newcomers—as many as 93 percent according to one survey—point to downtown as one of the main reasons they want to live in Naperville. The city's quaint downtown is definitely why so many people visit, although today many people visit downtown to eat and drink and browse through shops instead of to conduct daily errands as they did in the 1800s and 1900s.

Naper's town was filled with locally owned businesses. Today's Naperville is a mix of locally owned and national establishments.

Naperville's service businesses have slowly left downtown over the past couple of decades. In their place, more restaurants and national chain retailers have moved in. The one constant, however, is that Naperville's downtown has always been successful. Perhaps one reason is, at various times over the years, so many have worked so hard when downturns threatened. So far, what businesspeople have done seems to be working, although there is no denying the change.

Tom Klingbeil, born in 1941, worked most of his life at various businesses in the few blocks of downtown Naperville. As a kid, he mowed lawns where the city's central parking facility now sits. He cleaned up at the Tasty Bakery on Jefferson Avenue after school as a 15 year old making 80¢ an hour (he got up to $1 an hour by the time he was a high school senior). He worked at the Sports Bowl on Washington Street setting pins for 10¢ a line.

After serving in the military, Klingbeil came back home and cut meat at the National Tea when it was on Main Street and was working there when it moved to Jefferson Avenue. After graduating from Northern Illinois University, he had an opportunity to buy the City

Meat Market. With a $2,000 loan from his mom in 1972 and a loan from Harris Bank, it was his.

The downtown Naperville he remembers from the time he was a child in the 1940s was a commercial center where one could get almost anything. "There were two hardware stores, men's and women's shoe stores, two sporting goods stores, a five and dime, clothing stores—you could shop at Dean's or Horsley's or the Main Store. There was a bakery, a grocery store, a meat market, a Laundromat. You could buy cars downtown! You could park your car and do everything you needed to do within those 4-5 blocks, plus you could have dinner or lunch."

Klingbeil thinks of today's downtown as mostly bars and restaurants. "They used to have variety, that's the biggest change. That was one of the motivations for selling the business [in 1998]—downtown Naperville wasn't conducive to the meat market. Someone wasn't going to buy an occasional pork chop and carry it around. Now they're promoting it as an entertainment area, but that's what they have to do because that's what's there."

Klingbeil figures everything started changing when Wehrli Appliance and Soukups Hardware left downtown. Some complaints a few years later, including skyrocketing rents, were the result of a shift from mainly owner-occupied buildings to landlord-owned rentals.

Downtown did have some low periods, such as the 1970s, when interest rates were high and business owners had to work at getting people to come downtown. The Central Area Naperville Development Organization (CAN-DO), created a plan to renovate downtown to make sure it did not end up empty like many other downtowns in the state. It added nicer streetlights, more trees were added, and parking meters were removed in 1976; parking has been free downtown ever since. It is always scarce, as anyone driving around looking for a spot will say, but it is free.

In 1981 came the piece de resistance: the construction of Naperville's renowned Riverwalk along the DuPage River, what many refer to as the city's jewel. Downtown's proximity to the Riverwalk was definitely a big factor in its resurrection.

By 1984, a *Chicago Tribune* article described downtown Naperville as booming (the city was too—the population had doubled to 85,000 in the 1980s) and credited the Riverwalk for helping to keep the quaint, historic area vibrant. The scope of change downtown is evident, considering the 25-year-old story noted residents felt downtown "needs more family-friendly restaurants," a need that has been satisfied many times over in the past decade. A quote from longtime downtown businessman/councilperson/developer Alfred Rubin is particularly ironic 25 years later, now that Naperville's downtown is an entertainment mecca: "A lot of people who go to shopping centers or malls go for entertainment. Here, the businesses are destination locations."

Despite the feeling by some that there are too many restaurants and not enough stores—an opinion so strong that city meetings have been held to discuss (and toss out) the idea of limiting liquor licenses—downtown is still populated by both stores and restaurants, with locally owned and national or regional chains.

For every loss, a corresponding remaining treasure can be pointed to. Although the Candy Kitchen and the Rafter House are long gone, Naperville is still home to restaurants such as Jimmy's Grill and Potter's Place, as well as the independent Canterbury Shop gift shop.

Although the Mole Hole closed and a bar replaced it, the independent Naperville Running Company and Naper Nuts and Sweets remain just down the street.

But the slow exodus continues. As information for this book was being collected, one of their neighbors was about to announce a move from downtown after nearly 30 years and another independent store a block away was ending its 20-year run. Janet Smith's Hozhoni Gallery was closing, and Kay Clay Dancewear, where generations of Naperville girls were fit for ballet, tap, and jazz shoes, was ready for a store with more parking. "It's a desert land here now that everyone is moving—we don't get the walk-by traffic we used to," said manager Shynell Owen, herself a customer of the store since she was three years old. "It's not the same downtown I grew up with, it's all restaurants, bars and food."

Although it was hard to see Oswald's Pharmacy, downtown for 129 years, leave in favor of Naper Plaza, its sister store, Anderson's Bookshop, has thrived despite a huge chain bookstore

opening a few blocks away in 1998. As Bill Anderson of Oswald's said, just a year before he moved his store, "Visitors from across the country have come to downtown Naperville to try to discover our secret recipe for a successful shopping district. Like most successes, a little luck and a lot of hard work have gone into our 'overnight' transformation to today's lively commercial hub." Perhaps it is now too commercial, since Oswald's moved to a location better suited for a service business, with a bigger parking lot and two groceries next door.

Grocery stores, or rather the lack of them, have been a complaint of residents since CeeBee's closed in 1996. Years ago, Naperville was home to many grocery stores. Today there are none, even though one of the biggest growth sectors downtown is residential condominium buildings, and the single-family housing market adjacent to downtown has been lively, with tear-downs galore.

The buzzwords for the day in nearly every conversation and newspaper article about downtown are "the right mix" of retail and restaurant/bars. Everyone knows that is what is needed, but no one knows exactly what that is.

Anderson tried for more than two years to rent Oswald's to a retail tenant but finally gave in and rented to Ted's Montana Grill. A count in 2006 found 42 places to eat downtown. Meanwhile, 74 percent of people surveyed said they came downtown to eat, while just 16 percent said they came for a specific store. "What drives downtown is a dollar and what we're witnessing is where that dollar has taken us," Anderson said in 2007. "Right now, that's restaurants. What will follow is retail."

Today, after a successful move out of downtown that, even on the first day after reopening, saw Oswald's sales increase by 20 percent over the previous average day. Even as the number of customers dropped by 25 percent, Anderson is philisophical about the downtown where his business began and spent more than a century and a quarter. "It's nice that people get proprietary about downtown, but it is a living, moving thing. It goes through ups and downs. In the 60s and 70s when I was a kid, it wasn't such a joyful place to be. But what we have now is pretty fascinating," Anderson said.

The recent changes downtown were not caused by the economy or rising rents, Anderson said, but by today's culture. "It's who we are. People want to park in front and run in and run out. In a congested downtown, that's not going to happen."

The change seemed to begin in the late 1990s. A 1999 *Naperville Sun* article about smaller stores leaving downtown because of rising rents listed 13 new businesses coming to town, all of which were national chains, as opposed to the 10 independent stores and restaurants leaving. A 2006 map of downtown's shopping district listed 293 businesses, 170 of which were independent, although that number likely has dropped.

The fear is that downtown Naperville, which, for as long as most residents and their grandparents can remember, was a place filled with businesses carrying founding families' names on the signs, could become somewhat of an generic outdoor mall. Everyone seems to agree that "the right mix" must include locally owned and national chain establishments. "Everybody likes the combination of a Toenniges Jewelers and an Anderson's Bookshop with the major stores," said Bill Esser, president of the Central Area Naperville Development Organization, in 1999. "It's a great idea, but how do you do it?"

If anyone can figure that out, the people of Naperville can. For more than 175 years, they have supported businesses such as Scott's store, My Attic, the Midway café, the Stamp Shack, Kearns Feed and Supply, Wickerworks, Stark and Matter, the Kitchen Sink, and countless more. Napervillians are proud of the downtown they have now, especially because it has recently even grown to include Van Buren Avenue and more development plans in the works in areas such as Water Street.

Although the reasons for spending time in downtown Naperville are different than they once were, it must be remembered that the city, which began offering services for those arriving on horseback, despaired when automobiles arrived around 1911, necessitating paving the east side of the streets. Newspapers warned of "speed maniacs" in cars. Then, of course, there was a time not long after when four car dealerships ringed downtown.

Today Illinois's fourth-largest city and its neighbors heartily support downtown Naperville, its Riverwalk and trolley, its unique swimming hole, and its shops and restaurants. The downtown Naperville bar/restaurant scene on a weekend night, particularly in the warmer months, must be seen to be believed. However, the notion that this is something new falls apart when looking at how many of these photographs are old taverns. Naperville considered becoming anti-saloon territory in 1914 and obviously decided against it.

Through all kinds of change, Naperville's downtown will always be the heart of the city, the reminder of its past that somehow charms all who are lucky enough to spend time there—now and in the future.

One
AN OVERVIEW OF NAPERVILLE, LITERALLY

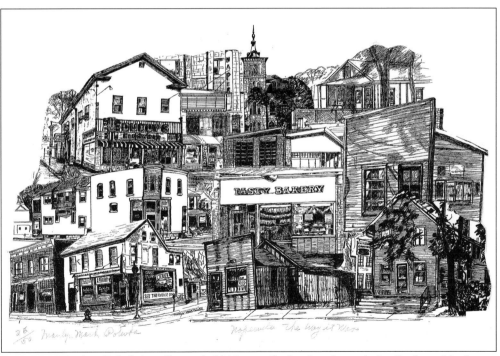

COLLAGE. Marilyn Polivka's collage of old Naperville landmarks includes Soukups Hardware, Tasty Bakery, Fidler's, the Naper Theater, Andy's Popcorn Stand, East Side store, Boeker's grain elevator, Burgess gasoline station, North Central College's Old Main, and the Beach Inn, all drawn from photographs she took after moving to Naperville in 1951. (Courtesy of Marilyn Polivka.)

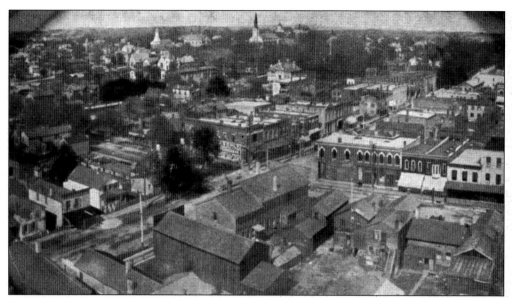

BIRD'S-EYE VIEW. Taken between 1906 and 1912, this still is the center of downtown Naperville. Buildings in the foreground made way for National Tea in 1961 and for Main Place shops in 1997. The street that ends in the bottom left corner is Jefferson Avenue, the bottom one perpendicular to that is Main Street. In the distance is the original Nichols Library and the SS. Peter and Paul steeple. (Courtesy of Steve Hyett.)

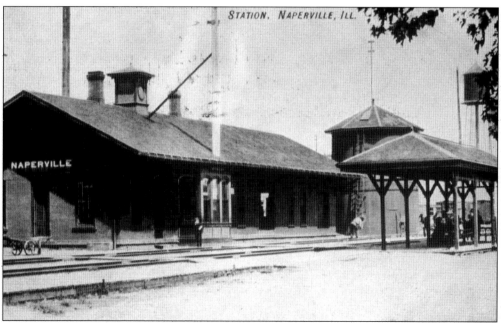

TRAIN STATION. In 1864, the Chicago, Burlington and Quincy Railroad arrived in Naperville, taking over the 1851 Southwest Plank Road to Chicago. Seen here is a photograph taken sometime before 1912 when this old station was north of the tracks at Ellworth Street. The water tower on the right is from the Kroehler factory nearby. Frames from the passenger shelter (right) were recycled along the Riverwalk. (Courtesy of Steve Hyett.)

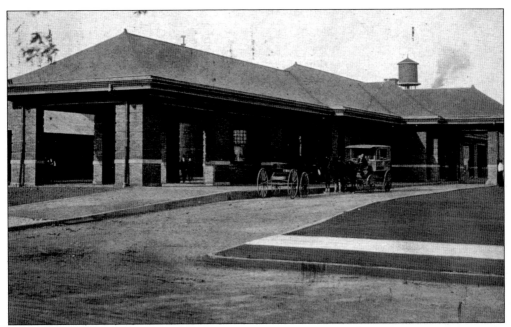

NEW DEPOT. The new and current Naperville depot was built on the south side of the tracks in 1912. Naperville's easy access to Chicago by rail helped fuel the city's growth. In the 1930s, an underpass was constructed for townspeople to cross safely under the tracks, a convenience drivers appreciate to this day. (Courtesy of Steve Hyett.)

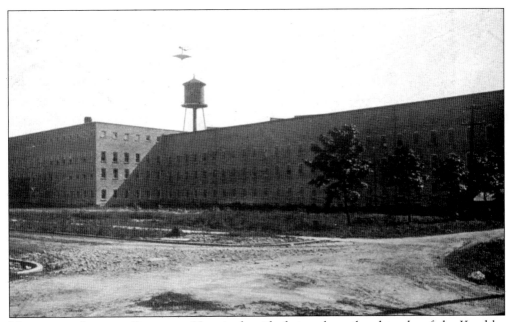

NAPERVILLE LOUNGE COMPANY. Here is the side facing the railroad tracks of the Kroehler furniture factory, located at Ellsworth and Fifth Avenue. Once considered the world's largest manufacturer of overstuffed furniture, the factory closed in the 1950s. In the 1970s, it was turned into a shopping/business/condominium center called Fifth Avenue Station. (Courtesy of Steve Hyett.)

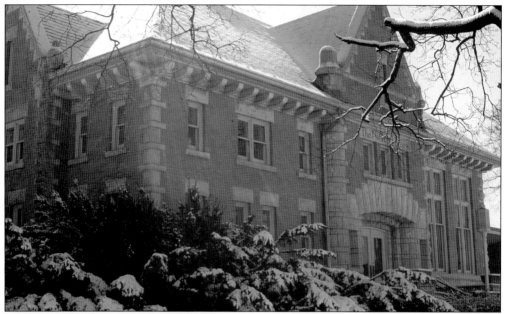

NICHOLS LIBRARY, 1910. North Central College professor James L. Nichols left two bequests of $10,000 each in his will, one for the building of a gymnasium on the college campus and one for a free public library in Naperville. The Nichols Library at 110 South Washington Street was built in 1898, opening with a collection of 700 books, 200 of which were donated by residents. (Courtesy of Steve Hyett.)

NORTH CENTRAL COLLEGE. Located just east of Naperville's business district, North Central College is a vital piece of the city. Founded in 1861 as Plainfield College and renamed North-Western College in 1864, it (wanting to relocate to a town on a rail line) moved to Naperville in 1869. Renamed again to avoid confusion with Northwestern University in Evansten, citizens offered trustees $25,000 to help construct a new building. Shown here is North Central's Wentz Concert Hall and Fine Arts Center, opened in 2008. (Courtesy of Steve Hyett.)

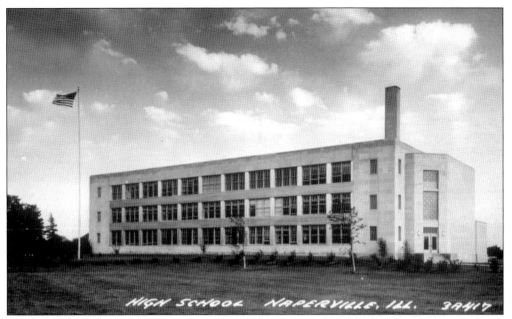

NAPERVILLE COMMUNITY HIGH SCHOOL. Built in 1951, this photograph of the school was probably taken around then, long before the many additions and the major renovation and rebuilding started in 2009. The school, known as Naperville Central High School since Naperville North High School was opened in 1967, is located on Aurora Avenue on the edge of downtown, not far from Main Street. (Courtesy of Steve Hyett.)

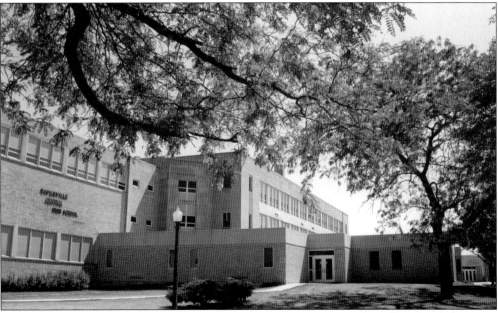

NAPERVILLE CENTRAL HIGH SCHOOL, 1997. Naperville Central High School, home of the Redhawks, will not look like this much longer. In 2008, after considering many options, including relocating the school or tearing it down and rebuilding on its current property, voters approved a massive reconstruction of the old high school, which began in 2009 and is expected to be complete in 2011. (Courtesy of Naperville Community Unit School District 203.)

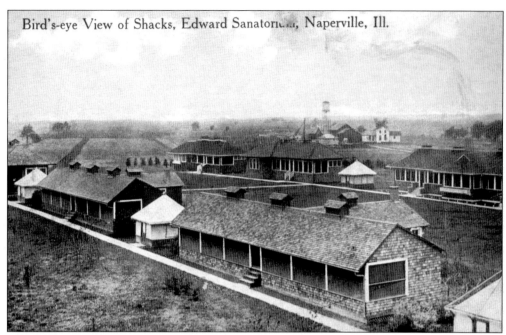

EDWARD SANATORIUM. Eudora Hull Gaylord Spalding founded Edward Sanatorium as a memorial to her husband, Edward Gaylord. It was one of the first treatment centers for tuberculosis in the Great Lakes region. In 1920, a fire destroyed the main building, and a fireproof structure was built. One of the sanatorium's big supporters at the time was Joy Morton, owner of Morton Salt Company and the founder of the Morton Arboretum in Lisle. (Courtesy of Steve Hyett.)

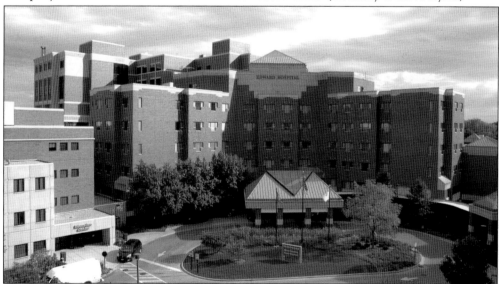

EDWARD HOSPITAL. After the tuberculosis epidemic, Edward became a community hospital, reopening in 1955 as an acute care facility with 45 beds. The first patient came in after being kicked by a horse. Edward became a public, tax-supported hospital in 1959 and in 1984, became a private, non-profit organization. Today, Edward Hospital and Health Services has 311 private patient rooms, 900 physicians, and is the 10th largest hospital in the Chicago area. (Courtesy of Edward Hospital.)

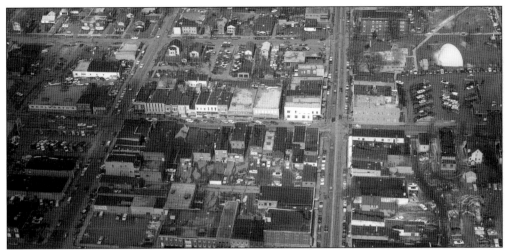

AERIAL VIEW. The downtown area is seen in 1973. Woolworth's, which opened in the early 1960s, is visible along West Jefferson Avenue near Oswald's Pharmacy and Koller Dodge. Washington Street is on the right running north and south, and above that, the city's old band shell in is Central Park. (Courtesy of Steve Hyett.)

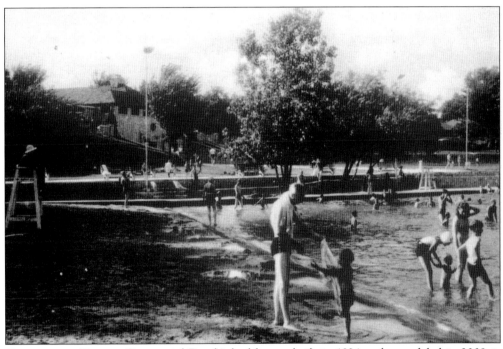

CENTENNIAL BEACH. Centennial Beach's bathhouse, built in 1934 and remodeled in 2009, is at the top left of this photograph, taken in the 1950s. Centennial Beach was a stone quarry on Jackson Avenue from the 1880s until it closed in 1917. After that, 39 Napervillians underwrote the cost of the 45 acres (donating $500 each during the Great Depression), creating Naperville's favorite place to swim. A 1931 centennial gift, it actually opened in 1932. (Courtesy of Steve Hyett.)

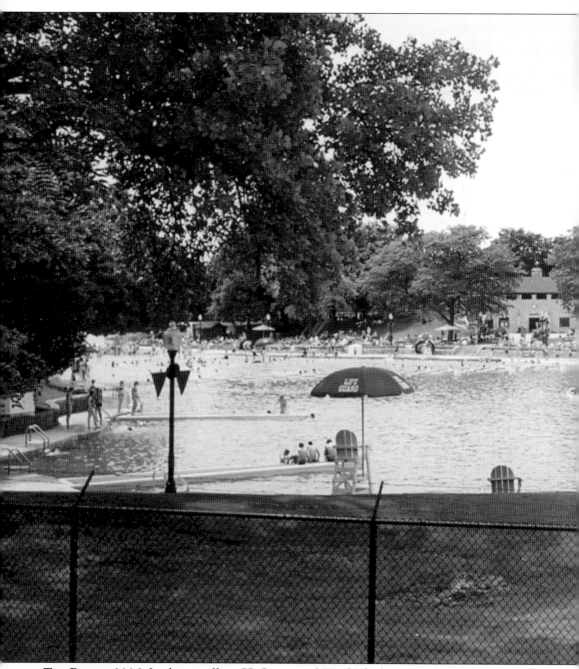

THE BEACH, 2006. Looking spiffy at 75, Centennial Beach's look was modernized in the early years of the new millennium, but care was taken to retain the historic, unique look of Naperville's swimming hole. A major renovation of the original bathhouse is planned for 2009. There are

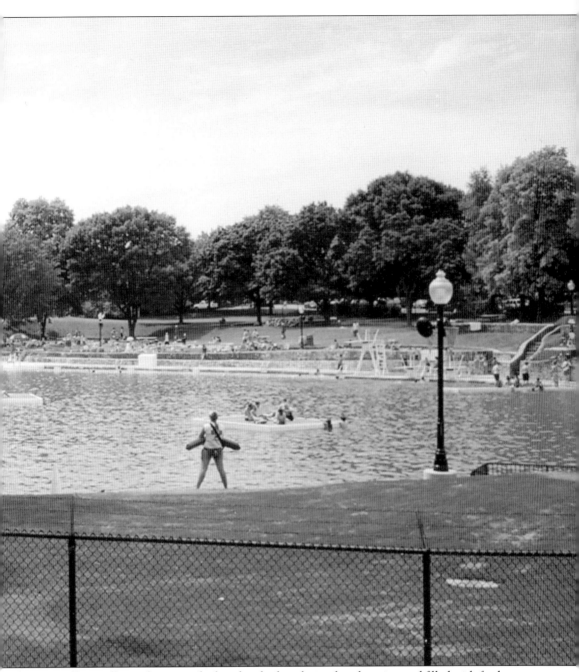

6.2 million gallons of water at the beach, which is drained each spring and filled with fresh water each April. (Courtesy of Naperville Park District.)

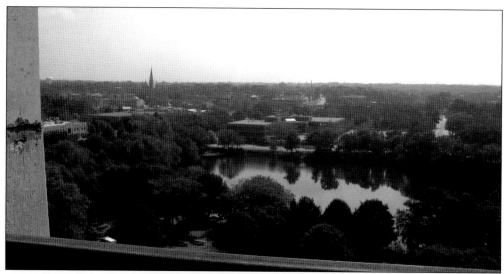

CARILLON'S–EYE VIEW. At 14 stories above the city (10 feet taller than the Statue of Liberty), the view from open-air observation deck offers a one-of-a-kind vantage point of 178-year-old Naperville. Visitors can walk the whole way or take an elevator half the way. On clear days, one can see that other city out there—Chicago. (Courtesy of Chuck Seidel.)

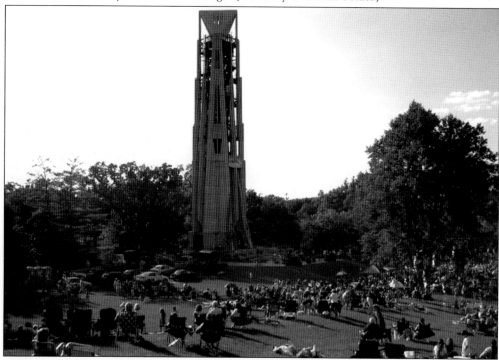

MOSER TOWER AND MILLENNIUM CARILLON. As 2000 approached, some Napervillians considered offering a gift to the city, such as Centennial Beach and the Riverwalk. In 1998, they decided on the carillon, an unusual instrument consisting of 72 bells inside a 160-foot-tall structure that towers over Naperville's Rotary Hill. It was paid for through donations from residents, a major gift from Harold Moser, and eventually, with city special events and culture. (Courtesy of Chuck Seidel.)

Two
THE SHOPS OF JEFFERSON AVENUE

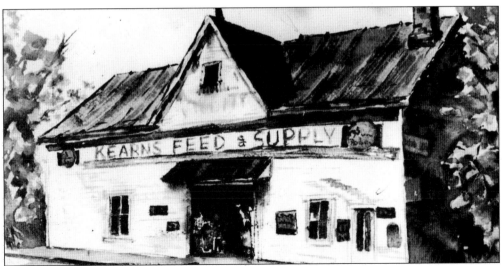

KEARNS FEED AND SUPPLY. Ed Kearns opened his Kearns Feed and Supply where Tom Peters's livery stable used to be. A garage was there for a few years until the late 1940s when Kearns opened his shop. The store offered just about anything a farmer needed, including, residents remember, baby chicks. That property, east of the fire station, was where Al Rubin later built a 20,000-square-foot Woolworth's in the early 1960s. (Courtesy of Mary Jane Draske.)

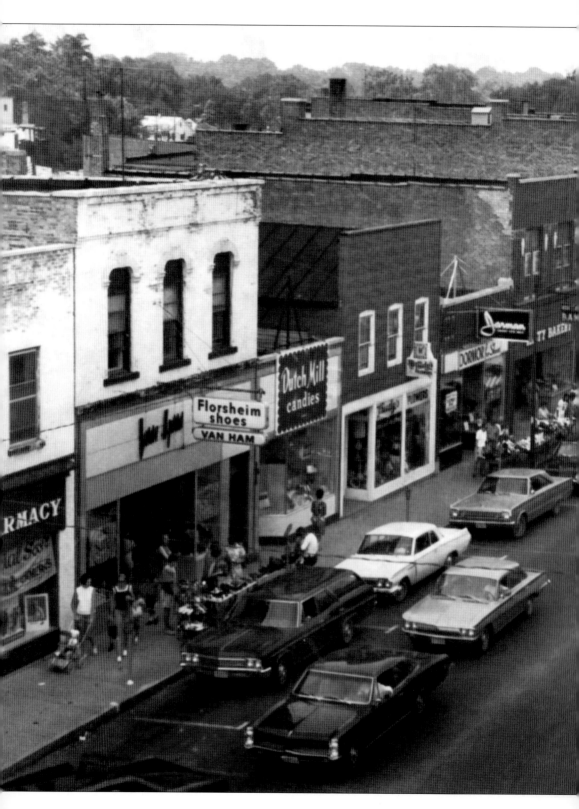

JEFFERSON FROM ABOVE, 1968. This is a great view of the south side of Jefferson Avenue during a summer sidewalk sale looking from Naperville Pharmacy, Van Ham's shoe store, and Dutch Mill Candies (today's Perle Jewelers), to Trudy's Flowers, a longtime fixture downtown in several locations. Trudy's storefront, once located at 10 West Jefferson Avenue, was Joe Egermann's saloon years ago, later King Realty, and since 1983 has been home to Naper Nuts and Sweets, founded by Dwayne and Amy Moss. (Courtesy of Naperville Sun.)

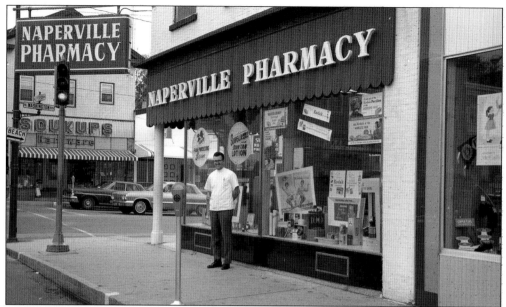

NAPERVILLE PHARMACY, 1963. Naperville Pharmacy occupied the southwest corner of Jefferson Avenue and Washington Street for 32 years, closing in 1985. Its well-used counter was a popular place for farmers to gather after morning chores and locals to grab coffee and breakfast for many of those years. Jeffries Walgreen, located there previously, offered a full restaurant service. That may be why the building has been a restaurant ever since. Check out the early-1960s Kodak products in the window. (Courtsey Kramer Photography.)

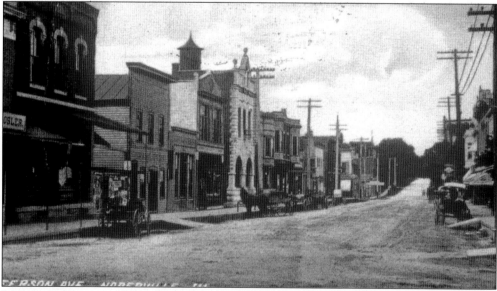

JEFFERSON AVENUE C. 1890. The south side of Jefferson Avenue looking west from Washington Street is much the same more than 100 years later, except for the dirt streets and wooden sidewalks. M. B. Hosler's shop is at the corner, 4 West Jefferson Avenue. Moses Hosler lived with his wife and three sons above his dry goods and grocery. The shop became Orlo Jeffries's drug store, the Naperville Pharmacy, Wilma's Café and, in 2001, Noodles restaurant. (Courtesy of Steve Hyatt.)

STARK AND MATTER. The southwest corner of Jefferson Avenue and Washington Street has been the center of Naperville's downtown as long as most people can remember. In 1917, the Exile Athletic Club was located above Eli Stark and Herb Matter's dry goods store. Pittsford and McAllister came next and then the series of druggists. Orlo Jeffries bought his Walgreen agency from Felix Czysz in 1945. (Courtesy of Naperville Sesquicentennial Photo Album.)

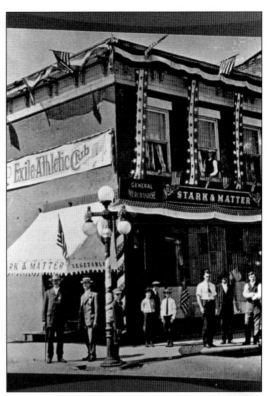

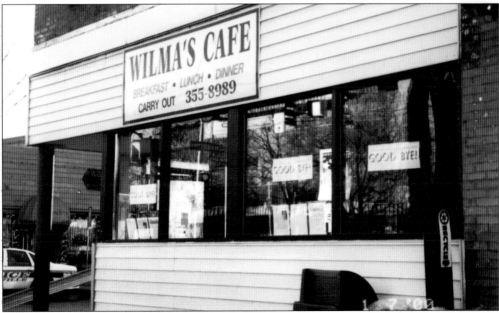

WILMA'S CAFÉ, 2000. Wilma's Café opened at 4 West Jefferson Avenue in 1990 and did not leave until forced out by a fire on December 1, 1999. Downtown neighbors mourned the loss of the quick, cheap, delicious food Wilma's offered, but the cost of repairing and upgrading the building to modern safety standards was too high for Wilma and Ken Patel, who moved their restaurant to Ogden Avenue after the fire. (Courtesy of Ken Patel.)

JEFFERSON FROM WASHINGTON. The view, looking west down Jefferson Avenue, has not changed much since the late 1930s or early 1940s. Naper Theater, which opened in 1935, can be seen down the block on the south side. The distinctive corner doorway of the Reuss building at the northwest corner of Washington Street and Jefferson Avenue on the right looks the same when clients enter today's Zazu Salon. (Courtesy of Kramer Photography.)

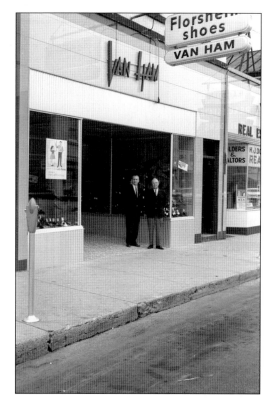

VAN HAM SHOES. John Van Ham opened his shoe store here in 1954 and moved to Jackson Street in 1968. The building was built in 1875 and began as a meat market, operated by Charles Boettger and his sons. In 1940, Frank Venos's barbershop was here, and then came the Leon Shop. In the 1990s, this was the popular Mole Hole gift shop, and in 2005, it became Rizzo's. (Courtesy of Kramer Photography.)

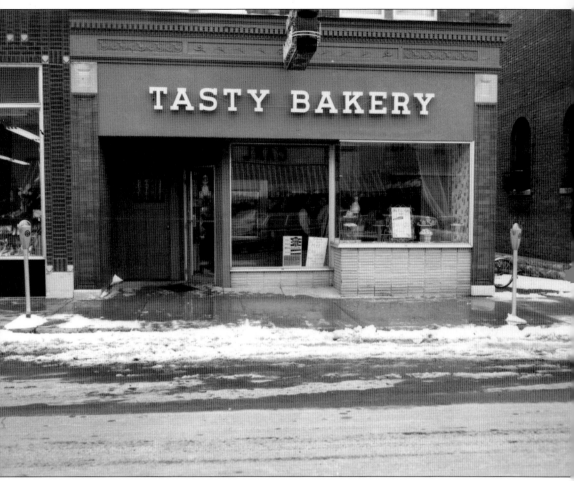

Tasty Bakery. Built for Ed Dieter's drugstore, 16 West Jefferson Avenue has catered to Naperville's taste buds since the 1920s. Until 1979, it was Tasty Bakery. The reflection of Carl Broeker and Company can been seen in the window of this pre-1976 photograph. Michelangelo's Pizza had a brief stay in the building before Leonardo Pizza's opened. Most recently, it was Brick House Pizzeria, and then after an addition in 2006, it became Tessa's restaurant. (Courtesy of Kramer Photography.)

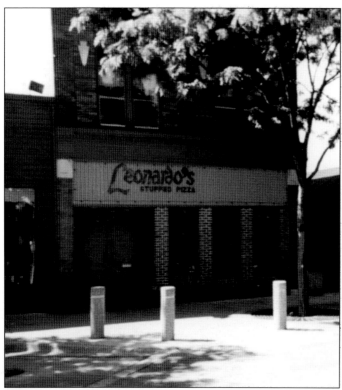

LEONARDO'S PIZZA. A Naperville institution for 21 years, Jim and Mary Fran Schenk and Lenny Lombardo opened this friendly hangout in 1981. Naperville, with a population of 31,000, had six places to eat downtown. Jefferson Avenue had mostly empty storefronts. The trio figured people would rather eat "Leonardo's" than "Jim's" pizza. From the sadness surrounding the restaurant's 2002 closing and the success of its grocery store frozen version since, apparently they were right. (Courtesy of Rose Barth.)

PERLE. Perle Jewelers, Naper Nuts and Sweets, Serendipity resale shop, and the recently closed Tessa's line are seen here on the south side of West Jefferson Avenue in 2009. Down the street before Ethel's pink and brown awning is Kay Clay, the dancewear shop that has been there for nearly 30 years. Dominique Martucci's Naper Nuts and Sweets is known for its shipments of popcorn to U.S. troops abroad. Serendipity was once Joe Egermann's chicken coop and later a post office. (Author's collection.)

CITY HALL. The City of Naperville purchased this building, one of the most distinctive in downtown, in 1917 for use as a city hall. City offices had been across the street at 13 West Jefferson Avenue on the first floor of a building owned by Carl Broeker before he constructed his brick store there. The bank moved to a more modern building at the northeast corner of Washington Street and Jefferson Avenue. (Courtesy of Naperville Sesquicentennial Photo Album.)

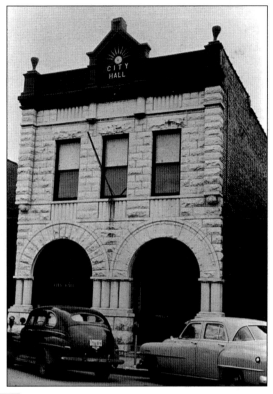

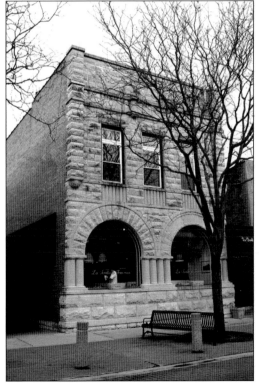

LA SORELLA DE FRANCESCA. Opened in 1994, La Sorella de Francesca was the first of many Chicago restaurants to open a downtown Naperville location. Chicago restaurateur Scott Harris liked Naperville so much that he opened a second restaurant on Ninety-fifth Street and Route 59 a few years later and encouraged his friend Jimmy Bannos to open a branch of his Loop restaurant, Heaven on Seven, downtown. (Courtesy of Kramer Photography.)

JAN'S GIFT HOUSE AND CANDLE CELLAR. For 47 years, Jan's Gift House was a fixture at 24 West Jefferson Avenue. It opened in 1955 and sold dime store–type merchandise and greeting cards. Later it specialized in candles, miniature collectable shoes, Lladro figurines, plate holders, frames, and a variety of Naperville-themed gift items. Owner Jan Hall sold the store to employee Kathy Goss in 1966. Goss's daughter Alice May bought it in 1989 and closed it in 2002. (Courtesy of Steve Hyett.)

RECONSTRUCTION, 1978. The reconstruction of Jefferson Avenue between Main and Washington Streets began May 31, 1978. The project took until mid-August, and cost approximately $370,000. Down the street on the left is the grocery store that was National and Cee Bee's. On the right, Russell's Dry Cleaning sign and the Busch sign on Fidler's precede the building where Anderson Bookshop is. (Courtesy of Tom Klingbiel.)

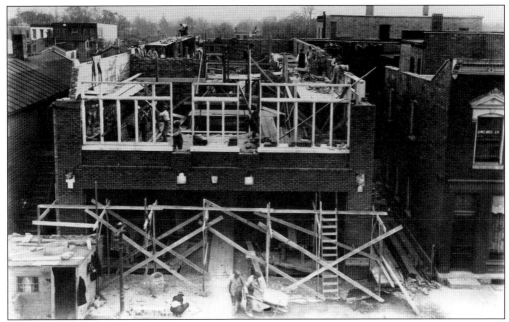

MASONIC TEMPLE CONSTRUCTION. Construction of the Masonic lodge building began in 1916 at 34 West Jefferson Avenue. The Masons use the second floor of this building for meetings while renting out the rear portion of the first floor to a silent movie theater in 1931 first and then to Sam Rubin's Chicago Bargain Store before a talking movie theater arrived in 1935. In 1979, Wehrli appliance moved in, and it later became Mary's Antique Mall. (Courtesy of Naperville Sesquicentennial Photo Album.)

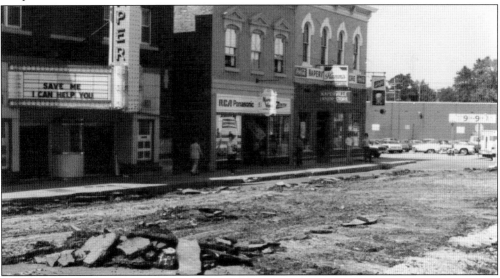

NAPER THEATER, 1978. "Save Me" appeared on the marquee of the Naper Theater, which closed in May 1977. Naper Video, a TV repair shop, and Naperville Liquors are visible farther west on Jefferson Avenue. The theater's demise was caused by larger cineplexes opening outside of downtown. Many were sorry to see the much-loved theater close; others used to complain they could hear the gavel in the theater when Masonic meeting was taking place. (Courtesy of Tom Klingbiel.)

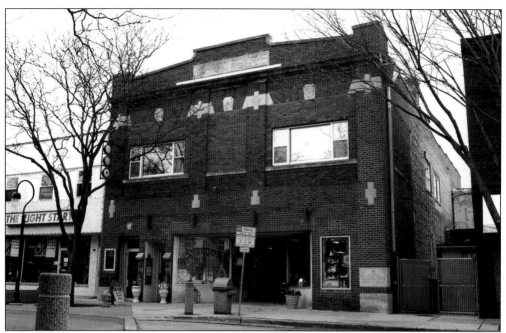

MASONIC BUILDING, 2005. In recent years, the Masonic building has been an antique mall. That closed in 2008 and a Lids store moved in. The Right Start was located next door to the east at 30 West Jefferson for several years after Laura's Hallmark closed. (Courtesy of Kramer Photography.)

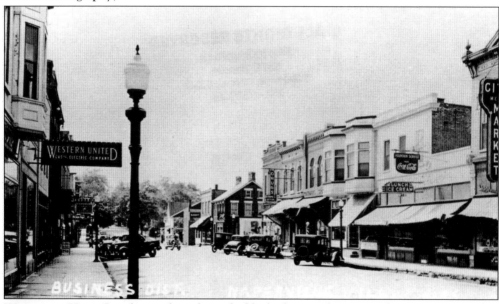

WESTWARD VIEW. Standing midway down the block, this was the view in the 1920s. Previously a millinery shop, Western United Gas and Electric occupied 28 West Jefferson Avenue in 1905. In 1936, Main Food Store moved here. Jim Wehrli's appliance store was here until moving down the block, and Continental Cupboard (1980s), Laura's Hallmark (1993–1999), and the Imaginarium/the Right Start (around 2002) were other tenants. Ethel's Chocolates opened in 2005 and closed in 2009. (Courtesy of Naperville Sesquicentennial Photo Album.)

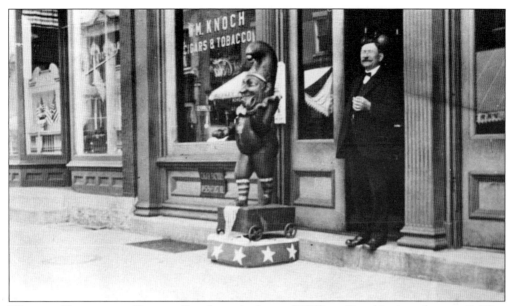

WILLIAM KNOCH AND PUNCH. Punch sat in front of William Knoch's cigar shop at 42 West Jefferson Avenue; the original Punch now resides at Naper Settlement. Known as the Shultz building, it was Shultz's cigar store until 1901 when William Knoch bought it for the cigar business he started in 1883 on Water Street (West Chicago Avenue). A cigar factory was in two rooms behind the store. The store was open until 1931. (Courtesy of Naperville Sesquicentennial Photo Album.)

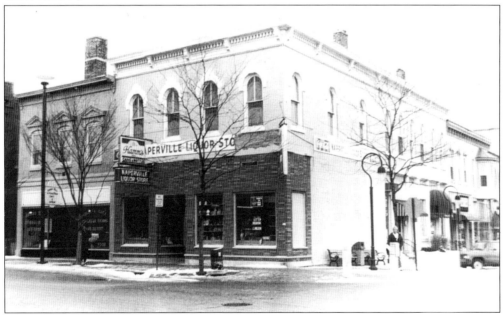

NAPERVILLE LIQUORS, C. 1976. The Schultz building was a liquor store starting in the 1940s. It was owned by Bill Spinner and Ed Patterman in the 1950s and by Stu Carstens from 1975 to 1985. The store was closed and building sold to Starbucks in 1993, and Napervillians have been buying a different sort of drink there since then. Next door to the east was Grandpa Mac's restaurant, which is now a Subway sandwich shop. (Courtesy of Stu Carstens.)

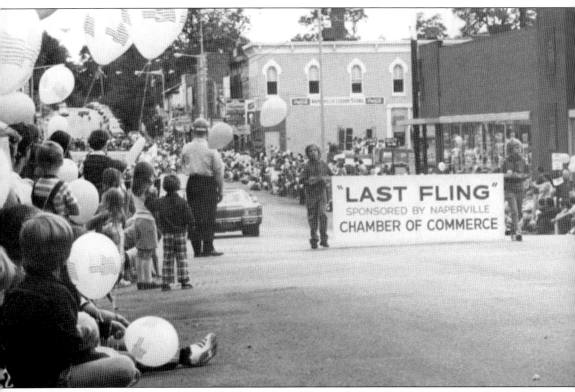

LAST FLING PARADE 1979. The Last Fling, Naperville's end-of-summer festival, has been celebrated each Labor Day weekend since 1965. The 1979 parade marched past the grocery store that began as National Tea and ended up as CeeBee's. Downtown Naperville hosts many parades yearly, including on Memorial Day and St. Patrick's Day. (Courtesy of Kramer Photography.)

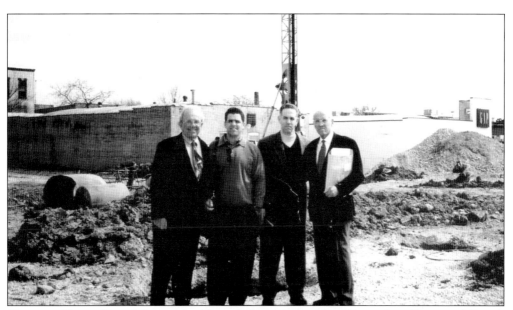

GROCERY GONE. From left to right, Norm Rubin, his son Sam, his nephew Steve, and Steve's dad, Alfred Rubin, gather at their development, Main Place, on West Jefferson Avenue in 1996. The Rubins tore down the CeeBee's grocery store that they had built in 1961 for National Tea for a development anchored by Eddie Bauer, Ann Taylor, and Wolf Camera on the block south of Main Street. Talbot's and the Gap on Main Street can be seen behind them. (Courtesy of Norm Rubin.)

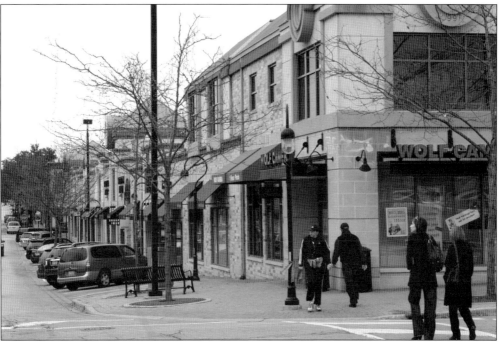

MAIN PLACE. From Wolf Camera at the southeast corner of Webster Street and Jefferson Avenue to Eddie Bauer at the southwest corner of Main Street and Jefferson Avenue, Main Place took up the entire block that used to be CeeBee's and its parking lot. (Author's collection.)

FIRE STATION. Naperville had one fire station in the 1940s on the north side of Jefferson Avenue. It was across the street previously. In 1912, the Historical Encyclopedia of Illinois called Naperville's Fire Department "one of the best volunteer companies in the state." The station moved to Aurora Avenue in 1992. The Jefferson Avenue building was remodeled, and a Lou Malnati's restaurant and the Naperville Chamber of Commerce moved in. Today Naperville has 10 fire stations. (Courtesy of Kramer Photography.)

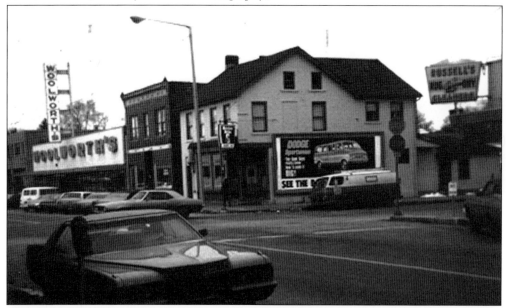

WOOLWORTH'S. The landmark on the west end of Jefferson next to the fire station loomed large when this photograph was taken in the 1960s, years before booklovers would take over that space. Al Rubin built the Woolworth's store, which opened in 1961. The Dodge billboard referred to the Koller Dodge dealership that was located down Main Street to the north of Fidler's. (Courtesy of DNA.)

THREE SHOPS. What was once Tom Peters's livery stable eventually became Kearns Feed and Supply in the 1940s. It was then replaced by Sam Rubin, who built Woolworth's. In 1973, Harold Moser converted the brick building into four stores. Three of them, Giesche Shoes, Addie's (owned by Addie Gartner, who moved her Kitchen Sink store there), and Paradise Bookshop, can be seen here. (Courtesy of Downtown Naperville Alliance.)

MALNATI'S. Lou Malnati's in the old fire station, Chico's in the old police department next door, and Anderson's Bookshop farther east are seen here in 2008. The other two shops in Anderson's Bookshop building are Gotskind's children's wear and Kaehler Luggage. Down the street is where Fidler's was at 103 West Jefferson Avenue. The most recent occupant, Hozhoni, a Native American gallery owned by Janet Smith, was at that corner for 25 years and closed in 2009. (Author's collection.)

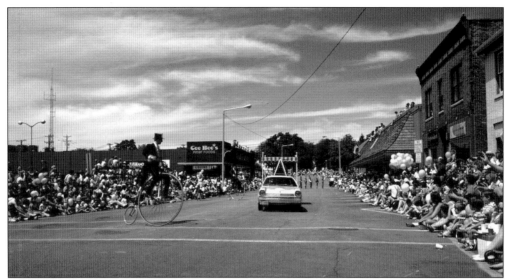

SESQUICENTENNIAL, 1981. Naperville's sesquicentennial was a three-day celebration including, of course, a parade downtown. The committee of both natives and newcomers recreated Joe Naper's three-day journey from Chicago to Naperville in horse-drawn wagons. This photograph features CeeBee's grocery store on the south side of West Jefferson Avenue and the shops on the north side. In this space years earlier was Bud Shimp's café. (Courtesy of Kramer Photography.)

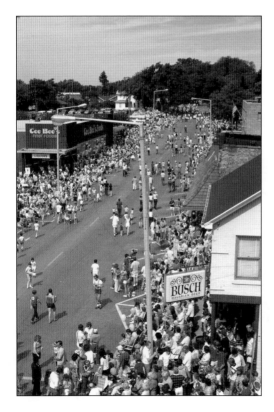

SESQUICENTENNIAL PARADE. Officials estimated the three-hour grand parade on July 5 attracted 100,000 people. Later that day, a lawn party raised money for the Riverwalk. This photograph features Fidler's and a view toward the current Nichols Library (built in 1986) that is just trees. Fidler's was Kenny Clark's and then Bob's Corner before it became a great cheeseburger place, tavern, and hangout. (Courtesy of Kramer Photography.)

DANCE AND SPORT SHOP. Taken a few years later, the well-loved Fidler's became a dance clothing shop at the northwest corner of Jefferson Avenue and Main Street. Blue Skies Albums and Tapes is still pictured, and this is the first sighting of the name Anderson's over the bookshop previously known as Paradise, which moved into 115 West Jefferson Avenue in 1971. "Paradise" was dropped because the word led many to believe it was a religious bookstore. (Courtesy of Charles Vincent George.)

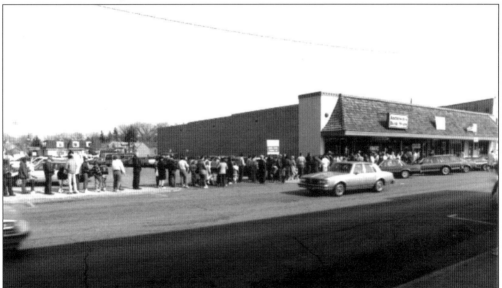

DITKA SIGNING, 1986. A sign of things to come was obvious in 1986 when Bears coach Mike Ditka came to Anderson's to sign copies of his book. The line snaked west on Jefferson, much the way it did many years later when the second Harry Potter book was released. The view through the parking lot reveals the way Van Buren Street looked at the time, including the old Beidleman-Kunsch funeral home building. (Courtesy of Bill Anderson/Anderson's Bookshop.)

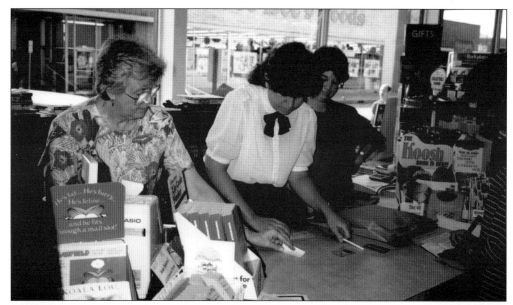

INSIDE ANDERSON'S. Perhaps taken on the same day as the Ditka signing and definitely in the same era, Anderson's Bookshop employees take care of their customers, as they still do in downtown Naperville, even after the arrival of the chain Barnes and Noble bookstore in downtown Naperville in 1998. Napervillians, however, continue to support the hometown store owned by Tres and Peter Anderson and their sister Becky Wilkins. (Courtesy of Oswald's Pharmacy.)

FIDLER'S TO HOZHONI. The northwest corner of Jefferson Avenue and Main Street in 2009 has not changed appreciably since 1973. At the corner, Hozhoni Gallery has offered Native American art for many years. Also seen are the Irish Way, Kaehler Luggage, Gotskind's, and Anderson's Bookshop. Past that, the old fire station can be seen. The roof rising above Hozhoni is NaperPlace apartments. (Author's collection.)

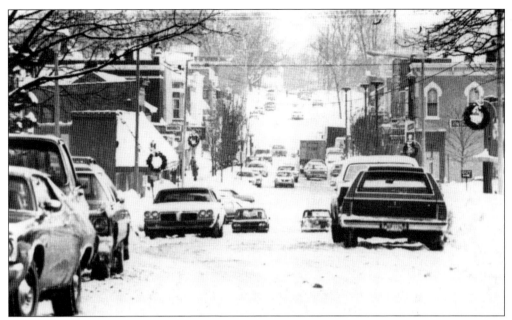

BLIZZARD, 1979. Looking east from just west of Anderson's Bookshop, the blizzard of January 1979 blanketed downtown. Just a bit of Fidler's Busch sign is visible, as are the signs for Russell's dry cleaning on the left, Naperville Liquors on the right at the corner of Main Street, and Esser Insurance at the northwest corner of Jefferson Avenue and Washington Street. The venerable Naper Theater sign has disappeared for good from Jefferson Avenue. (Courtesy of Steve Hyett.)

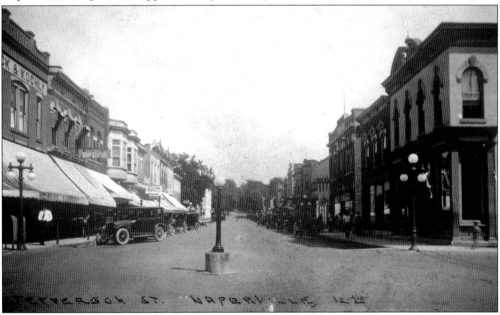

LOOKING EAST. This is an eastern view of Jefferson Avenue taken about 1920 from Main Street. Slick and Kochly's general store on the left is where Russell's dry cleaning opened in 1967 and remained into the 21st century. On the north side of the street on the left, the "drugs" sign is Oswald's Pharmacy's and the "ice cream" sign is Naperville Candy Kitchen. (Courtesy of Steve Hyett.)

EVERYWHERE SIGNS. Between the parking meters lined up like popsicle sticks and the signs competing for space, these two blocks of West Jefferson Avenue in the 1960s do not look much like they do now, despite the fact that all of the buildings are exactly the same. (Courtesy of Naperville Sesquicentennial Photo Album.)

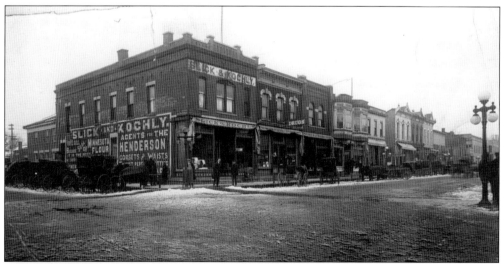

SLICK AND KOCHLY, 1905. Here is an even older view of the northeast corner of Jefferson Avenue and Main Street, which began as a general store owned by Martin Brown. In 1897, Benjamin Slick and Joseph Kochly, former employees of Scott's general store, bought the building and opened a grocery and dry goods store. Dr. A. B. Slick's dentist office was on the second floor until the mid-1950s. The awning next door reads W. W. Wickel Drugs. (Courtesy of Kramer Photography.)

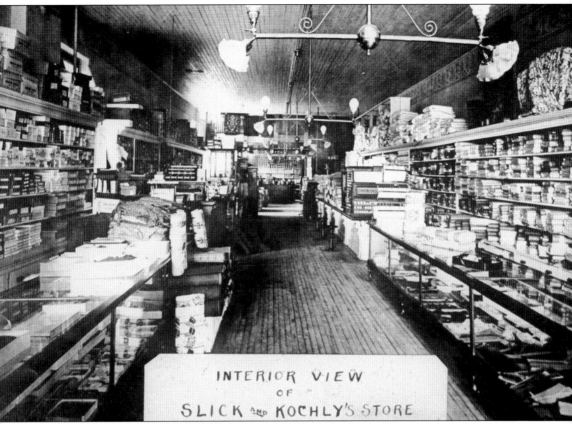

INSIDE SLICK AND KOCHLY. This is the interior of Slick and Kochly's grocery and dry goods store, the occupant of 41 West Jefferson Avenue for years. The store was followed by an A&P store in the 1930s. In 1950, it became the second location of Aurora's Main Store, a general store managed by Dean DeGeeter, who eventually opened Dean's boy's clothing store down the street. This photograph was taken in 1908. (Courtesy of Steve Hyett.)

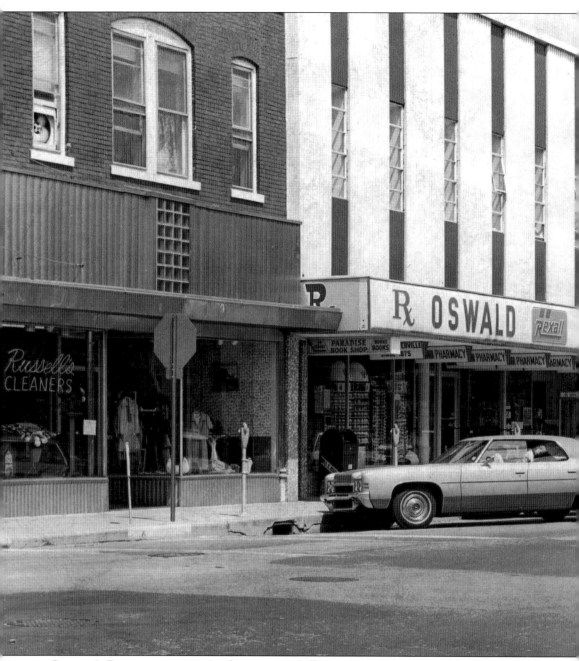

OSWALD'S PHARMACY, 1973. Looking east up Jefferson Avenue from Oswald's Pharmacy, the first sign under the awning identifies Paradise Bookshop upstairs. The Rexall sign is white here; the previous orange sign was destroyed when a cigar humidor caught fire. Down the north side

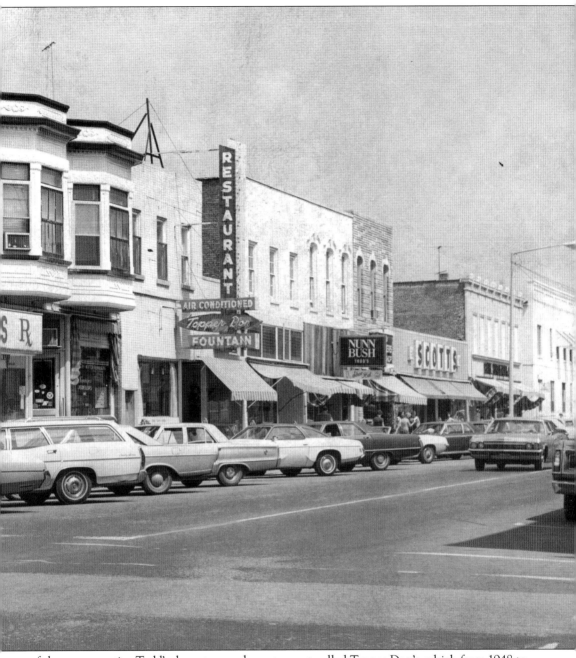

of the street, notice Todd's shoe store and a restaurant called Topper Don's, which from 1948 to 1956 was called the Candy Kitchen and then the Intermission. (Courtesy of Naperville Sun.)

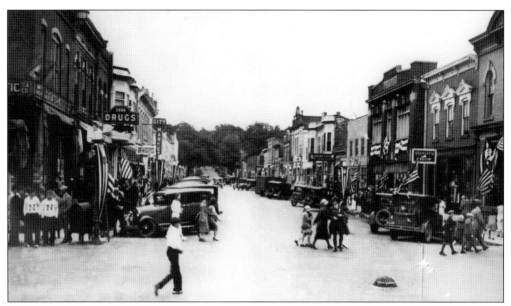

JEFFERSON AVENUE AND MAIN STREET, 1931. These Naperville lettermen celebrated the city's centennial in 1931. The two-day celebration included a succession of juvenile parades downtown where "youngsters showed off their dolls and their pets in quaint costumes and vehicles." The former Slick and Kochly on the left is an A&P store, located there until 1941. In 1963, Ralph Breitweiser bought the building. Russell's dry cleaning opened in 1967, owned by Russ Breitweiser, who operates the store to this day. (Courtesy of Kramer Photography.)

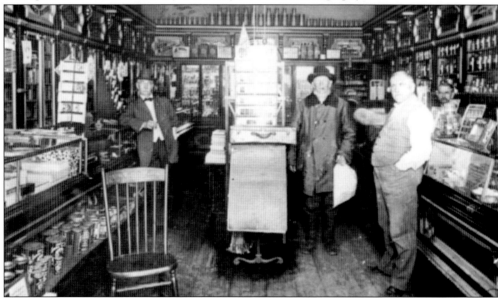

W. W. WICKEL. William Wallace Wickel left Pennsylvania and moved to Naperville, where, in 1877, he bought an existing two-year-old drugstore that was 500 square feet. It sold typical wares of the day, including medicines, seeds, and animal tonics. In 1881, Wickel purchased the building at 39 West Jefferson Avenue. In 1909, Louis Oswald, Wickel's son-in-law, bought the store and changed the name to Oswald's Pharmacy. Oswald later sold to his son-in-law, Harold Kester. (Courtesy of Downtown Naperville Alliance.)

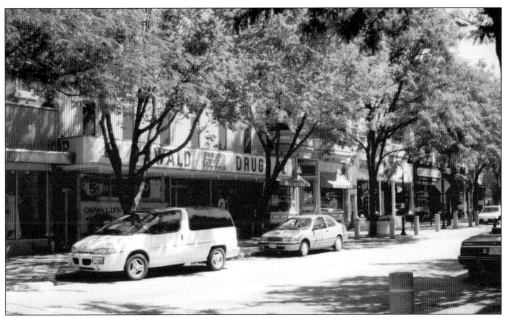

OSWALD'S, 1996. By 1996, the view had not changed much—notice Potter's Place Mexican restaurant at 29 West Jefferson Avenue where Topper Don's had been. On July 24, 2004, Bill Anderson decided to move the pharmacy to the Naper Plaza shopping center at Washington Street and Gartner Avenue. Oswald's Pharmacy was one of many service businesses that left downtown around that time. (Author's collection.)

TED'S MONTANA GRILL, 2009. It took a couple of years before Anderson found the right tenant for his building, but in 2007, Ted's Montana Grill opened where Oswald's Pharmacy had been for so many years. The old aluminum facade was removed to reveal the brick underneath. Next door, Costello's Jewelry has its new, larger store, and just past that is Potter's Place, which opened a remodeled patio at the rear of the restaurant. (Author's collection.)

47

TOENNIGES JEWELERS. This is a 1970s view of a timeless institution. For 51 years until November 1999, Dorcas Toenniges Pearcy's store occupied 33 West Jefferson Avenue. When Pearcy, known as a "huge force for the downtown area," retired and sold the building to Costello Jewelers (which expanded next door in 2006), many called it the end of an era for downtown Naperville. Considering the subsequent shift to restaurants and chain stores, it was. (Courtesy of Steve Hyett.)

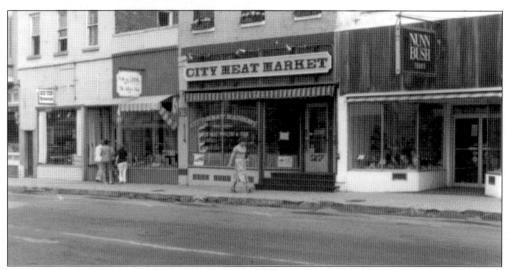

CITY MEAT MARKET, 1978. Another of downtown's longest-standing businesses, City Meat Market was at 27 West Jefferson Avenue from 1890 until March 2004, when it moved to Ogden Avenue. For 20 years before that, Faulhaber's City Market operated on the south side of Jefferson Avenue. The building housed Pfister's Hardware in the early 1900s. Next door in this 1978 photograph is the Big Top Restaurant before it became Potter's Place. (Courtesy of Tom Klingbeil.)

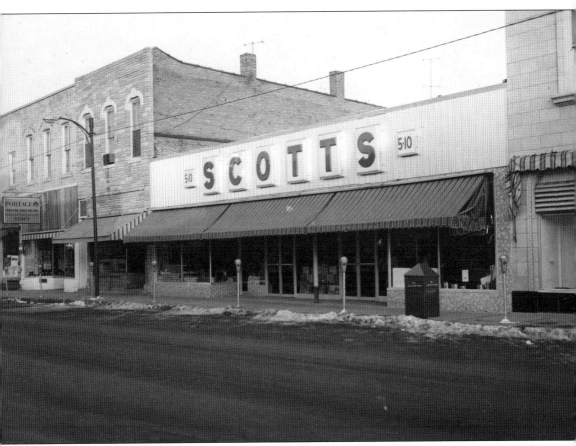

SCOTT'S. George Burckal's Saloon and Tom Saylor's confectionery used to be located here at 19 and 21 West Jefferson Avenue in a building constructed in 1869. The College Inn was here in 1900, and it was a National Tea grocery store in the 1920s. In 1945, the building was torn down and a brick one was constructed, and Ben Franklin was located there for years. In this 1960s photograph, it is Scott's five-and-dime. (Courtesy of Kramer Photography.)

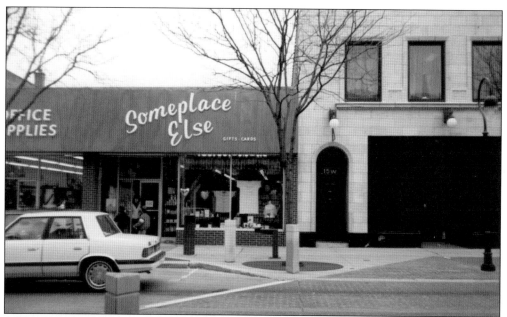

SOMEPLACE ELSE. The east side of Scott's was Trish Shetina's Someplace Else cards and gifts from 1979 to 2004. The store filled with "fun stuff for kids from one to 100" was a favorite of a couple of generations of Naperville kids. This photograph was taken before Someplace Else's 2000 expansion from 2,000 to 6,500 square feet into the home of Village Stationers next door. (Courtesy of Rose Barth.)

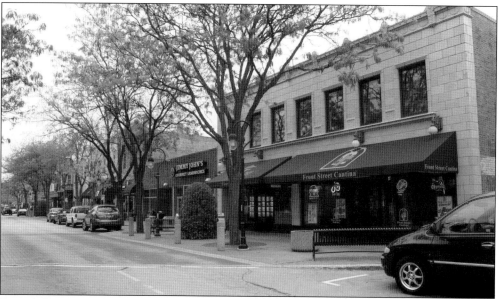

FRONT STREET CANTINA. Opened in 1993, Front Street Cantina, which puts tables in front during warm weather, is located in the eastern half of the old Carl Broeker's store. Ryan Hill Realty is in the other half, and Jimmy John's sandwich shop occupies part of what was once Someplace Else. Front Street Cantina's first location on Wheaton's Front Street is called Front Street Cocina because Wheaton's laws did not allow any reference to liquor in restaurant names. (Author's collection.)

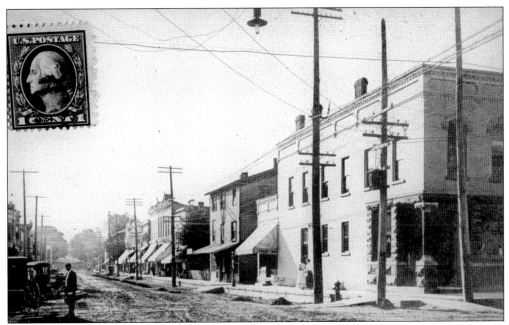

NORTHSIDE JEFFERSON AVENUE. Here is a view of the north side of the street a century ago. Reuss State Bank, with its diagonal door, is on the corner at 135 South Washington Street. The building was constructed in 1860 by dry goods merchant and tailor George Reuss as Reuss Clothing Store, and in 1897 became Naperville's first bank. For many years, it was Esser Insurance and in 1998 became Zazu Salon and Day Spa. (Courtesy of Steve Hyett.)

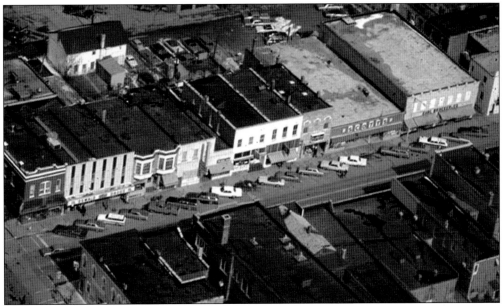

AERIAL VIEW. Seen here is a complete picture of what the north side of Jefferson Avenue from Main Street to Washington Street looked like in the early 1970s, just after Oswald's old orange Rexall sign was replaced with a white one. Carl Broeker's store was still at 13 West Jefferson, where it was built in 1927 and remained until 1982. In 1993, it would become Front Street Cantina. (Courtesy of DNA.)

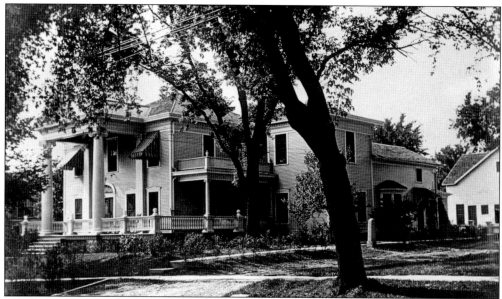

KENDALL HOME. The home of Francis A. Kendall at 43 East Jefferson Avenue was built in 1945. The Naperville Veterans of Foreign Wars hall was named after his son Judd, a Naperville mayor. Kris Guill bought the building from her mother in 1987, but it had been in the family since 1972. Guill's dad, George Olson, was an architect with an office in the building. He won an award for the 1988 addition that more than doubled the building's size. (Courtesy of Naperville Sesquicentennial Photo Album.)

JEFFERSON HILL SHOPS. Popular hangout Quigley's tavern, opened in 1998 on the lower level, and Looks salon, on the right, occupied the Jefferson Hill Shops in 2009. The famous Jefferson Hill Tea Room, opened in 1974 by building owner Shirley Olson, moved upstairs when Quigley's moved in then closed to much fanfare and regret in 2006. U.S. Bank's drive-through facility is to the left of the shops. (Author's collection.)

Three
WASHINGTON STREET, WHERE IT BEGAN

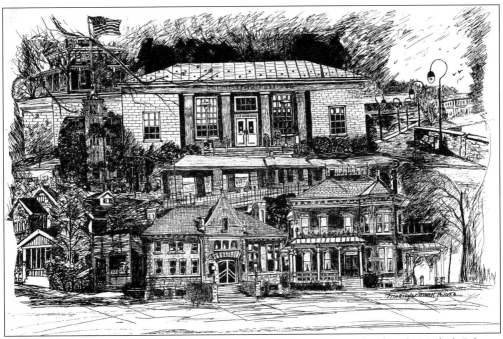

LANDMARKS. Marilyn Polivka's collage includes Washington Street landmarks Nichols Library and the post office as well as the Naperville Riverwalk, North Central College's Old Main, the stonecutter building from Jefferson Avenue (later Andy's Popcorn Stand), the train station, and the Martin-Mitchell house. (Courtesy of Marilyn Polivka.)

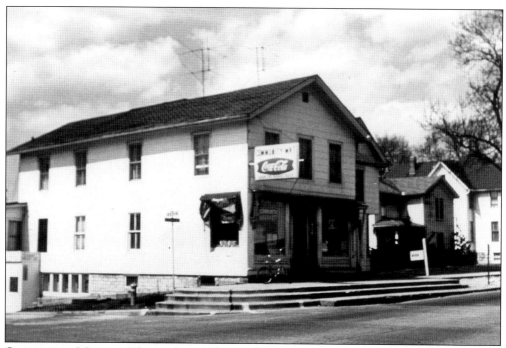

COMMUNITY MARKET. The market on the northeast corner of Washington Street and Benton Avenue was operated by Henry Doolin and John Pollard as late as the mid-1950s. (Courtesy of Naperville Sesquicentennial Photo Album.)

YMCA. The Peter Kroehler YMCA became a reality after a community fund drive that raised $26,260 in a town of 2,000 that had been deemed too small for a YMCA. The cornerstone was laid on Memorial Day in 1910, and the three-story building at 34 South Washington Street was dedicated on March 26, 1911. Upgraded in 1948 and added onto in 1973 and 1978, it remains a vital piece of downtown Naperville today. (Courtesy of Steve Hyett.)

NICHOLS LIBRARY. Additions to Nichols Library were constructed in 1925 and 1962 to keep up with Naperville's growth, and it remained at 110 South Washington Street until 1986, when a new facility, five times larger, opened at 200 West Jefferson Avenue. This building today houses Truth Lutheran Church. (Courtesy of Steve Hyett.)

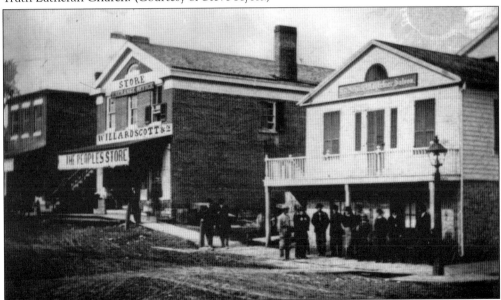

PEOPLE'S STORE, C. 1850. Willard Scott's general store on Washington Street opened in 1842 at the northeast corner of Washington Street and Jefferson Avenue approximately where the north half of the Naperville National Bank and the south half of the Naperville Sun building were in the 1950s. The store was expanded in 1876 and the second floor featured a large hall with a balcony and a stage to host plays, concerts, and political rallies. (Courtesy of Naperville Sesquicentennial Photo Album.)

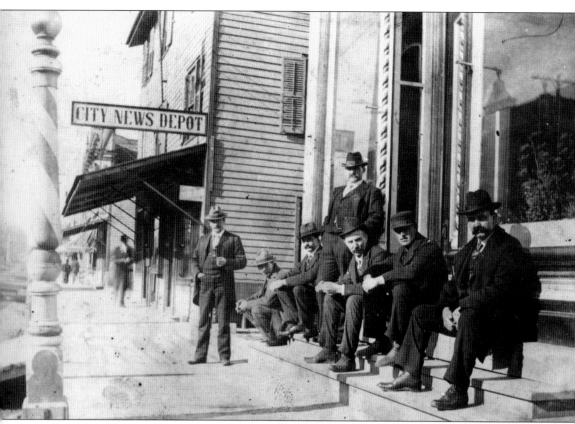

CITY NEWS DEPOT. These men were gathered on the steps of the Scott's building on Washington Street near Jefferson Avenue. Williard Scott's general store offered groceries, dry goods, hardware, and clothing. In 1876, Willard Scott Jr. opened Scott's Hall, a dance hall, theater, and community center. In the late 1920s, Clarence Croft's Spanish Tea Room opened there. (Courtesy of Kramer Photography.)

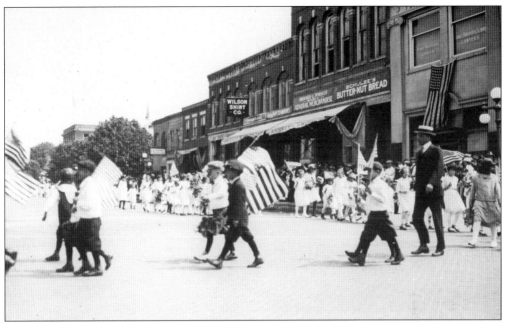

DECORATION DAY. This photograph was taken sometime after 1910 at the northeast corner of Washington Street and Jefferson Avenue. On the east side is the building that became Naperville National Bank, and the YMCA is in the distance by the trees. The awning says "Broeker and Spiegler." (Courtesy of Steve Hyett.)

CENTER OF TOWN. This is the northeast corner of Washington Street and Jefferson Avenue sometime after the YMCA was built in the early 1900s. The YMCA's roof is visible at center on the right. Looking north on Washington Street at the east side where the U.S. Bank is today, the old post office is on the corner. (Courtesy of Steve Hyett.)

NAPERVILLE NATIONAL BANK. The Naperville National Bank was constructed at the northeast side of Washington Street and Jefferson Avenue in 1934 and remodeled in 1951. Soukups Hardware is across Jefferson Avenue at the corner, and Herb Matter real estate is across Washington Street to the south. Past there is Naperville Realty, Beidleman's, and the Standard gasoline station. (Courtesy of Kramer Photography.)

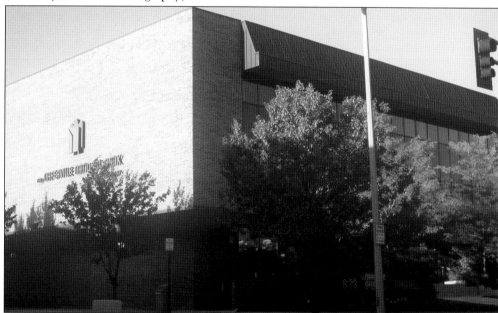

NEW NAPERVILLE NATIONAL BANK. This is the newer version of Naperville National Bank. The bank was organized in 1934 by Napervillians including Win Knoch and Walter Fredenhagen. Harold Moser was chairman of the board in 1970. Eventually this bank changed hands many times to become First Wisconsin, Firstar, and currently it is U.S. Bank. (Courtesy of Steve Hyett.)

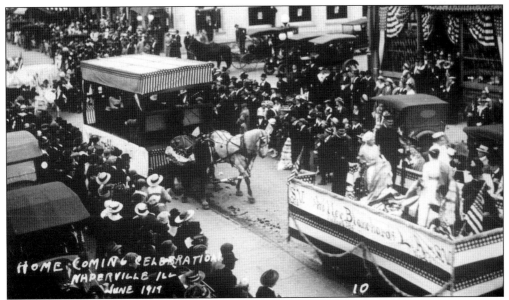

HOMECOMING, 1917. The homecoming parade marched south on Washington Street past Jefferson Avenue. The building at top center is where the Naperville National Bank was later built. At the top right is the southeast corner of Washington Street and Jefferson Avenue where Soukups Hardware later opened. The awning says "hardware"; it was Scherer's Hardware from the 1880s to 1946. The building was constructed by Capt. Morris Sleight in 1858. (Courtesy of Steve Hyett.)

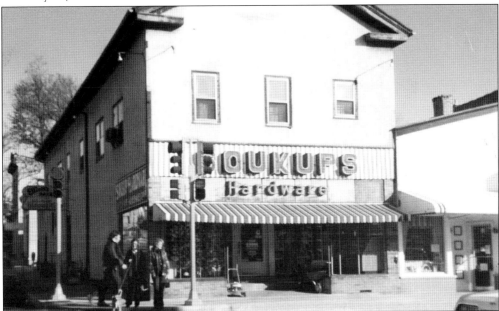

SOUKUPS. Soukups Hardware store was so iconic that it was incorporated into one of Naperville's Century Walk murals. This was how it looked anchoring the center of town at the southeast corner of Washington Street and Jefferson Avenue in the late 1950s or early 1960s. It opened in the 1880s and was owned by Christian Scherer and his brother-in-law George Yost. In 1950, Frank Lisjake bought it, and it was affiliated with Soukups stores. (Courtesy of Marilyn Polivka.)

ROSELAND, 2008. Roseland Draperies and Interiors celebrated its 25th anniversary at this corner in 2008. The business started in the 1940s in the Roseland neighborhood of Chicago. Mary Ann Junkroski's brother bought the small chain in the early 1970s, and Junkroski, a resident since 1975, opened the Naperville store in 1983. Even now, people still tell Junkroski about when the store was Soukups Hardware and how "that guy had everything." (Author's collection.)

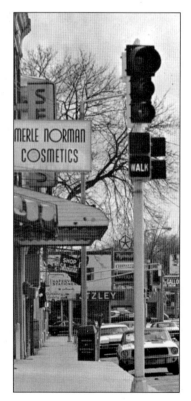

MERLE NORMAN. Standing approximately in front of Soukups, this is a great view south at the entire stretch of the east side of Washington Street as it looked in the late 1960s and early 1970s. Merle Norman, Sears, Silhouette Shop, Naperville Stationers, a bit of the Sports Bowl marquee, Netzley's Plymouth/Chrysler, and the Cock Robin are seen down the way. (Courtesy of Downtown Naperville Alliance.)

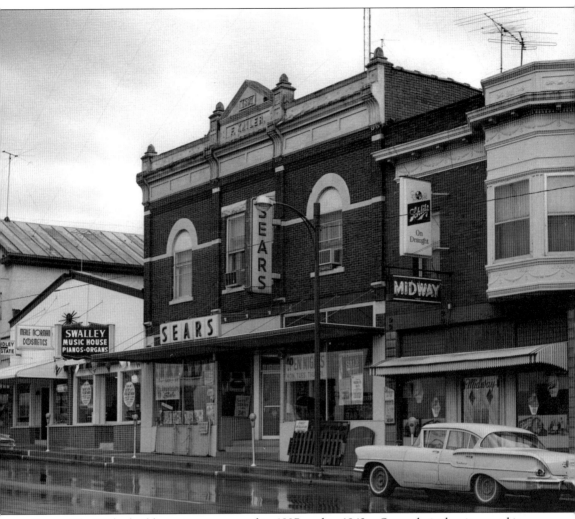

Sears. The Kailer building was constructed in 1897, and in 1943, a Sears clerical unit moved in. Two years later, Sears opened an order office. Nichols Publishing occupied a back portion of the second floor during the 1950s when this photograph was taken. Midway Café, which opened in 1940, was located just south of Sears. (Courtesy of Kramer Photography.)

SOUTH WASHINGTON STREET, 1953. The three buildings on the right were replaced by a one-story brick structure after this 1953 photograph was taken. The left building, 222 South Washington Street, had been a grocery and crockery store, a barbershop, and the dining room of the Rafter House. To the right was the Rafter House restaurant, which opened in 1946 and closed before this photograph was taken of Sam Rubin's buildings. (Courtesy of Naperville Sun.)

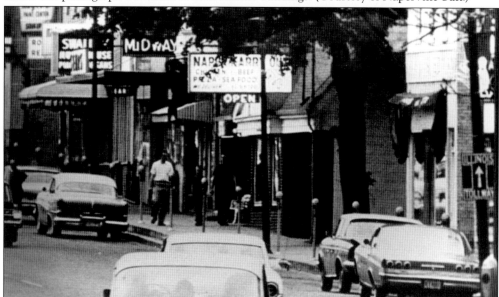

SOUTH WASHINGTON STREET. Bustling Naperville, in the days when Interstate 88 was Illinois 5, is seen here. The Illinois Tollway sign is on the right (the east–west toll road plans were announced in 1954). This is the east side of Washington Street looking north from approximately Jackson Avenue. From left to right, Naperville National Bank is at the far corner, and Soukups Magicolor sign is at the near corner followed by Swalley Music, the Sears mail-order store, Midway café, and Naperville Karry-out Chicken. (Courtesy of Naperville Sesquicentennial Photo Album.)

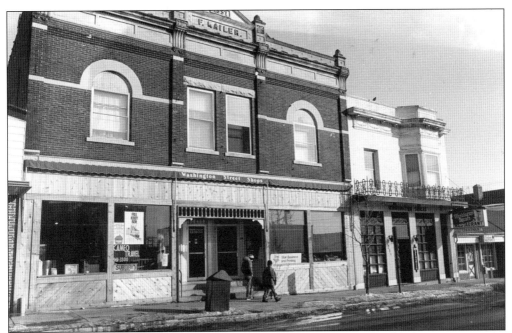

WASHINGTON STREET. Here is the Kailer building when it was divided into two stores called the Washington Street Shops, and when Midway Lounge to the south was turned into the Washington Square restaurant. Cameo Travel also occupied one of the storefronts. (Courtesy of Downtown Naperville Alliance.)

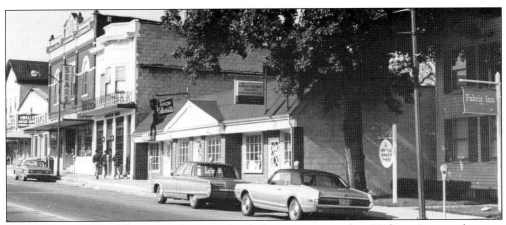

SILHOUETTE SHOP. This is a photograph of the same area after Midway Lounge became Washington Square restaurant in 1967. Looking north on Washington Street at the east side of street, the Fabric Inn is where Two Bostons is today, the Naperville Chamber of Commerce is where a dress shop is today, and the Forget Me Not Shoppe is now Harry Yaseen jewelers and the Silhouette Shop. (Courtesy of Downtown Naperville Alliance.)

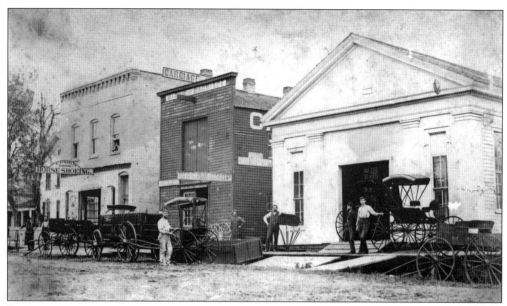

BLACKSMITH, WAGONS, AND CARRIAGES. In the late 1800s, Strubler Blacksmith and Hiltenbrand Wagon and Buggy Shops were located at 236 South Washington Street. The frame building in the middle was the repair shop, and the building on the right was the old Baptist church turned carriage showroom. Strubler was a Naperville native, born there in 1837. He started his blacksmith and horseshoeing business in 1854, adding wagons and carriages three years later on Washington Street. (Courtesy of Kramer Photography.)

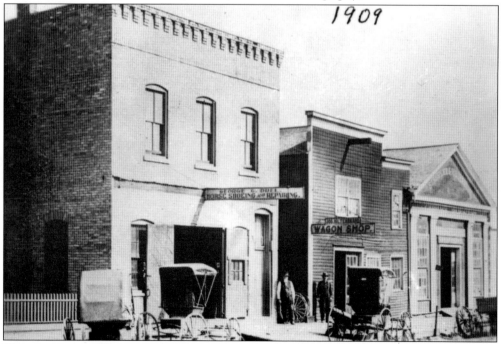

HORSESHOES ON WASHINGTON. A view from the opposite side, this 1909 photograph shows that Daniel Strubler later left the blacksmith business. The name on the horseshoe and repair shop now is George G. Duel. (Courtesy of Kramer Photography.)

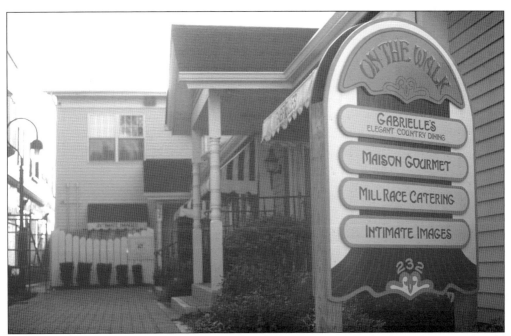

ON THE WALK. Gabrielle's restaurant was located at 232 South Washington Street in the old Strubler home. The O. J. Beidlemans lived there in the 1950s. The Strubler's blacksmith shop was located to the south of their home, where the Potbelly Sandwich shop is today. (Courtesy of Steve Hyett.)

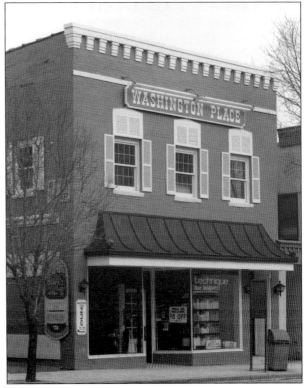

WASHINGTON PLACE. Andy Haas and Ed Getz remodeled the old blacksmith shop in the mid-1940s, added on to the back, and put a new storefront on it for their plumbing business at 236 South Washington Street. In the 1970s, Phil Walz operated the plumbing shop. In this late 1980s or early 1990s photograph, Technique Hair Designers have moved in and Subs and Company is around the corner. (Courtesy of Kramer Photography.)

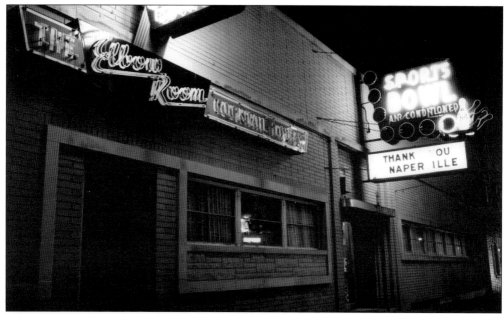

SPORTS BOWL. The old carriage showroom was used for a while as a warehouse then torn down in 1941. The Elbow Room was built on that site. Bill Feldott bought the Sports Bowl in 1948, running it until he closed it in May 1994. The building was torn down in 1997 to make way for a Dwight Yackley development, including Barnes and Noble, Restoration Hardware, and Corner Bakery. (Courtesy of Kramer Photography.)

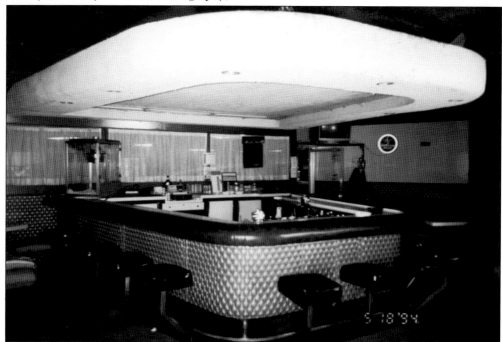

INSIDE ELBOW. This is the interior of the Elbow Room on South Washington Street as it looked in 1994. It was a small, dark, and popular place that connected to the bowling alley. (Courtesy of Rose Barth.)

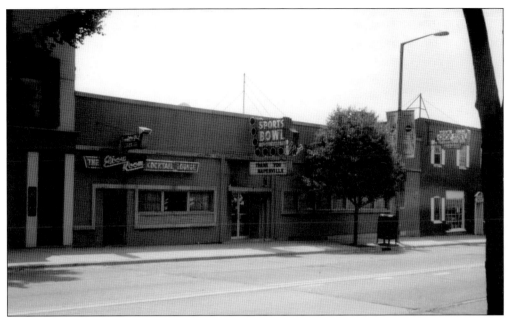

SPORT BOWL AND ELBOW ROOM. Here are the Sports Bowl and Elbow Room as they looked in 1994 after they closed. The corner building had been F. S. Goetsch and Son until the building was remodeled in the 1960s. Tong Inn, with its well-known chop suey sign, was at the corner at 246 South Washington until moving to Ogden Avenue. In 1998, the entire corner was replaced by the Washington Corners development. (Courtesy of Rose Barth.)

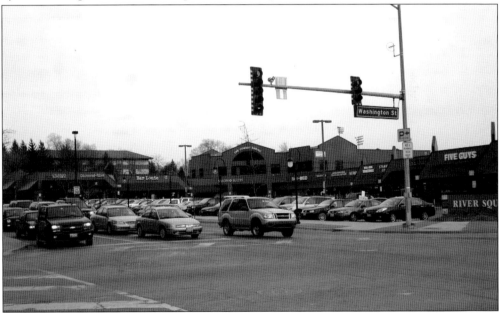

RIVER SQUARE. The southeast corner of Washington Street and Chicago Avenue has been home to River Square since 1989. Though plagued with a small, difficult-to-maneuver parking lot, the center has had many successful businesses such as the Rocky Mountain Chocolate Factory, Bar Louie, Jamba Juice, Salon Suites, and Timpano restaurant. Deanne's Papers and J. B. Winberie are former tenants still missed by locals. (Author's collection.)

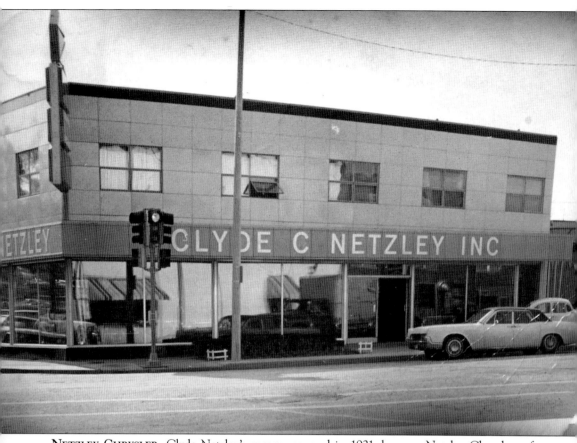

NETZLEY CHRYSLER. Clyde Netzley's garage, opened in 1921, became Netzley Chrysler a few years later. Clay Netzley has notes from his grandfather chronicling his sales calls, including one regarding a potential customer whose "mother doesn't believe" in automobiles. Clyde died in an automobile accident in 1935, but his widow, Eva, and her second husband, Harry Ridley, continued on with the business as did Clyde's son, Bud Netzley. The dealership was built on the former Lewis Rich property. (Courtesy of Clay Netzley.)

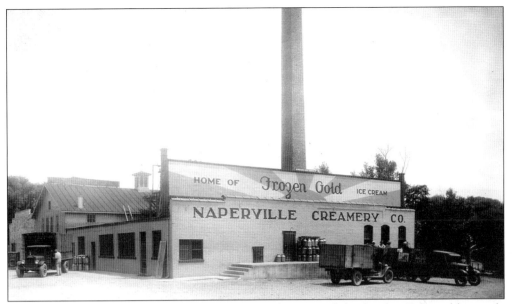

FROZEN GOLD CREAMERY. In 1920, Walter Fredenhagen, with his brother Don and his uncle Martin, bought the former Consumers Company creamery at 324 South Washington Street. The creamery had begun as the Farmer's Cooperative shortly after the Civil War. Products included ice, milk, and ice cream. They called their ice cream Frozen Gold, and indeed it was. In 1930, Fredenhagen sold the wholesale ice cream business to Borden. (Courtesy of Rita Fredenhagen Harvard.)

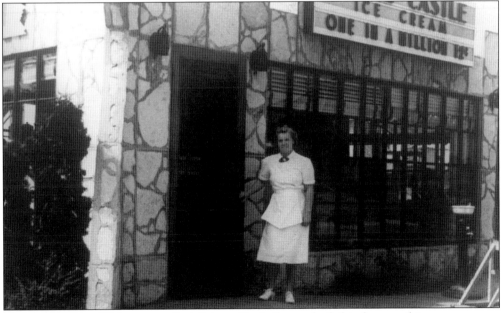

PRINCE CASTLE. With partner Earl Prince, Fredenhagen built his first retail ice cream store, the Naperville Prince Castle, in the 1930s in front of the ice cream plant next to the river on Washington Street. At two pints for 10¢, the ice cream was an affordable Depression treat. Eventually, there were 23 of these retail stores, and each was "One in a Million." (Courtesy of Rita Fredenhagen Harvard.)

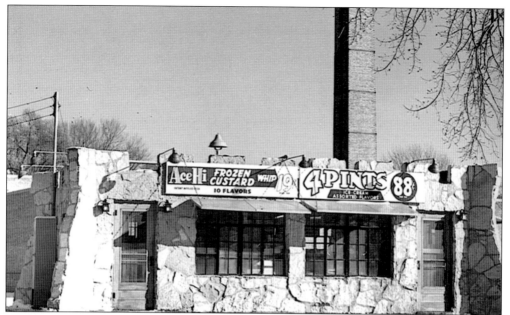

ACEHI. Here is the remodeled store in 1942. The chain famously used square dippers for portion control of ice cream and was the first to use see-through cabinets, allowing customers to watch their cones be scooped and filled. The partners hired Ray Kroc (who went on to McDonald's fame) to sell their innovative Multi Mixer product that made several milk shakes at a time. (Courtesy of Rita Fredenhagen Harvard.)

COCK ROBIN, 1982. This is the Cock Robin sign that for so many years marked the edge of the Washington Street bridge. Prince Castle changed its name to Cock Robin in 1954 after Earl Prince's death. Despite the odd name, the chain thrived through the 1960s, becoming one of the Midwest's largest restaurant chains. This view is from just north of Jackson Avenue looking south on Washington. (Courtesy of Naperville Sun.)

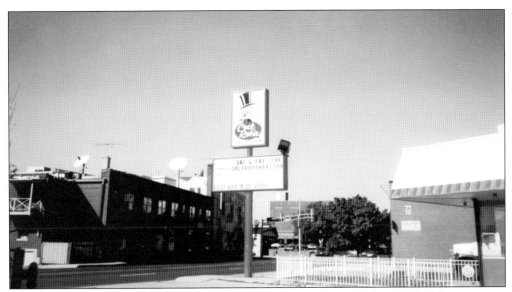

GOODBYE, COCK ROBIN. "Last Day 9/30/2000," read the marquee before the building was torn down on September 1, 2001. The chain struggled since losing the ice cream market share to grocery stores in the 1970s, and the last Cock Robin in Brookfield closed in 2008. Its soft butter toffee, however, remains. Every fall, Walter Fredenhagen's great-grandson makes 12,000 boxes to be sold in Naperville at Casey's Foods and Naper Nuts 'n' Sweets and by Mary Lou Wehrlis. (Courtesy of Rose Barth.)

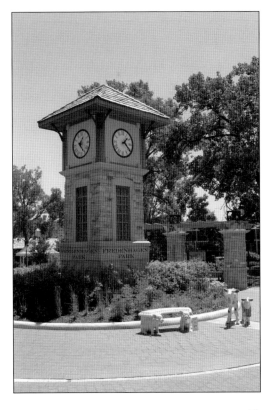

FREDENHAGEN PARK. Dedicated in 2003, the land on which the Prince Castle and Cock Robin stood became Fredenhagen Park. The land was donated to the city by Fredenhagen's children, Rita Harvard and Ted Fredenhagen. The park features the Exchange Club Memories Fountain, a replica of Cock Robin's square scoop. Residents purchased bricks and stones for the unusual fountain. A Century Walk statute of Grace and Walter Fredenhagen, called Two in a Million, also is featured. (Courtesy of Neil Gates.)

BURGER KING. Just south of Fredenhagen Park at the easternmost end of Aurora Avenue is where Burger King has been since the mid-1960s. Except for the new sign out front, the building looks the same as it has for many years. Next door is a vacant building that has also sat there for many years, awaiting renovation. (Author's collection.)

WASHINGTON STREET BRIDGE. In November 1977 after the bridge was reconstructed, this was the view from just beyond Cock Robin, looking north on Washington Street. The Lantern is on the left, and just past that are Bev Patterson's Pianos and Organs and Beidleman's Furniture. Locals remember back when a group of kids known as "the bridge sitters" regularly hung out on the east side of the bridge. (Courtesy of Naperville Sun.)

LANTERN. Taken in 1982, just north of the previous photograph, this view looks in the opposite direction toward the south on Washington Street. Chicago Avenue businesses in view are the Lantern at the corner, Dave's Flower Shop (in the first of its several Naperville locations during the past 59 years), and even a small bit of the Netzley Chrysler dealership on the east side of Washington Street at Chicago Avenue. (Courtesy of Naperville Sun.)

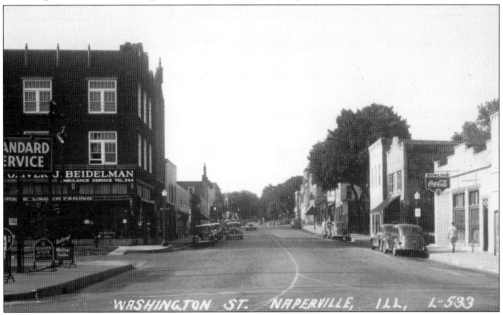

STANDARD. Originally the site of Beckman Harness shop, a restaurant was built here in 1912 and then it became a garage. Herbert Thompson rented it in 1916; in the 1920s, it became a Standard Oil station run by several owners until 1944 when Charlie Burgess took it over. This shot was taken some time after Beidelman's new building was constructed in 1928. The bowling sign shows the Elbow Room was not yet at that corner. (Courtesy of Steve Hyett.)

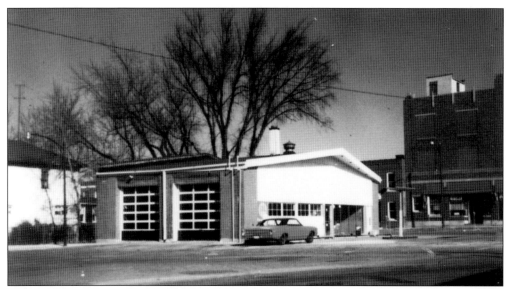

BURGESS STANDARD. Charlie Burgess sold his station on Washington Street between Jackson and Chicago Avenues to Bev Patterson Frier in 1970. Her piano and organ sales business eventually expanded into four locations. She sold the business in 1987 but still owns the property at 245 South Washington Street. (Courtesy of Marilyn Polivka.)

BEFORE JIMMY'S. Frier's business is gone, and the Landmark restaurant occupies the space at 245 South Washington Street in this photograph taken sometime between 1988 and 1993, before Jimmy's Grill arrived in December 1997. During the warm months, Jimmy's patio is filled with customers enjoying the weather, as well as the food and drinks. (Courtesy of Steve Hyett.)

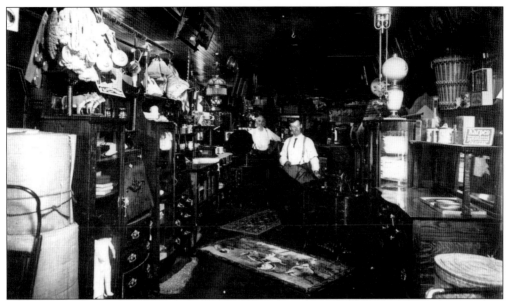

FRED LONG'S. This is the interior of Fred Long's furniture and undertaking. Long's nephew Oliver Beidelman went to work for him in 1898. Long made lounges in his upholstering shop in the back of the store at Washington Street and Jackson Avenue and was one of the original partners of Peter Kroehler's Naperville Lounge Company, which became the Kroehler Manufacturing Company. Beidelman took over in 1911 and constructed the current brick building in 1928. (Courtesy of Kramer Photography.)

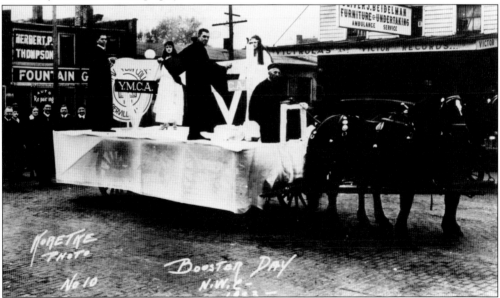

PARADING PAST BEIDELMAN'S. The Booster Day parade of North Western College (later North Central College) goes past Beidelman's store in 1923. Beidelman's family lived on the second floor of 231 South Washington Street (recently BK Jewelers and currently Tranquility Day Spa), and on the first floor was the Beidelman appliance store and Marian Cooper's beauty salon. In the background is Herbert P. Thompson's Naperville Garage on Washington Street and Jackson Avenue. (Courtesy of Lana Heitmanek.)

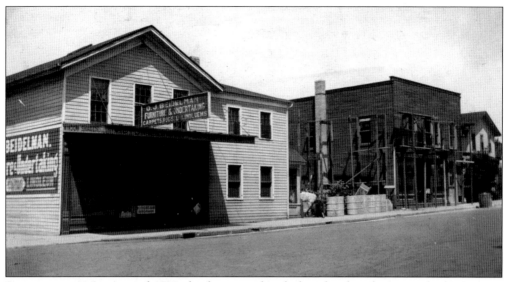

BEIDELMAN, 1924. Around 1924, the furniture shop before the chapel area was built. Carpets, rugs, and linoleum were added to the products offered. The brick building to the right is 231 South Washington Street. Oliver Beidelman's sons Owen "Dutch" and Wilbur joined their father's business by the mid-1950s. (Courtesy of Lana Heitmanek.)

WASHINGTON STREET AT NIGHT. Just north on Washington Street from Beidelman's, the Sherwin-Williams paint shop, Herb Matter Real Estate, Naperville Pharmacy, Foremost Liquors, Pure gasoline station, and the Phillips 66 are all on west side. On the east side in this mid-to-late-1960s photograph, a chicken and pizza place and the Silhouette shop are in view. (Courtesy of Givler family.)

SOUTH WASHINGTON STREET, 1997. At about the same stretch of Washington Street, the Chocolate Key, the tiny candy shop that sold delicious shaved ice, is visible at 217 South Washington Street. Looking north, Washington Square restaurant is on the east side of the street next to Carzz Grilleria and the Riverwalk Emporium. Past Roseland Draperies at the corner of Jefferson Avenue, Firstar Bank is in the distance. (Courtesy of Kramer Photography.)

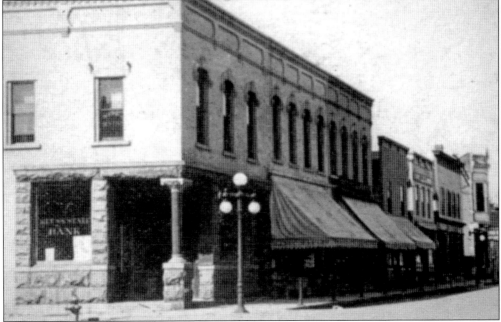

DIAGONAL DOOR. Here is an undated photograph of the northwest corner of Washington Street and Jefferson Avenue. This distinctive building began as George Reuss's dry goods store, and then became Reuss State Bank. In 1941, it became Esser Insurance, founded by Howard Esser, a name Napervillians remember at that corner for many years. (Courtesy of Steve Hyett.)

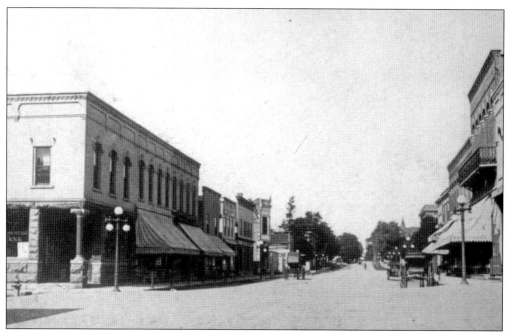

WASHINGTON CORNER. A wider, more complete shot shows both sides of Washington Street north of Jefferson Avenue with the horse and buggies of the time. Attorney Ben Piper's law office was in the rear of the Reuss State Bank building beginning in the late 1930s, and after the bank left, he rented out safety deposit boxes that remained. (Courtesy of Steve Hyett.)

LAST FLING PARADE. The roof of the Esser Insurance building was a great spot from which to view the 1979 Last Fling parade. Originally run by the Naperville Chamber of Commerce, the Jaycees took over the last fling in 1981. The event features a parade, a carnival, games, children's activities, live music, and food vendors along Jefferson Avenue. (Courtesy of Naperville Sun.)

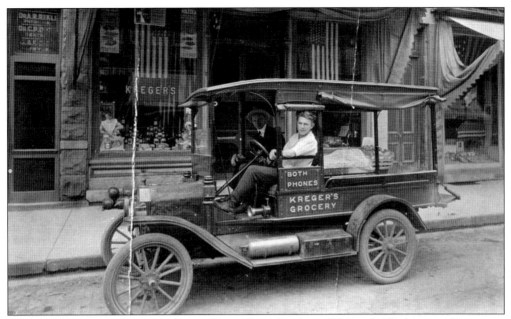

KREGER'S GROCERY. Just next door to Reuss State Bank at 133 South Washington Street was Valentine Dieter's grocery. The son-in-law of George Reuss sold his shop when Reuss opened the bank, and it was bought by J. V. Kreger. Illinois Bell Telephone later had its business office in this building, which is A-1 Antiques today. (Courtesy of Naperville Sesquicentennial Photo Album.)

YESTERDAY AND TODAY. Zazu Salon and Day Spa is on the northwest corner of Washington Street and Jefferson Avenue, A-1 Antiques is next door, and Le Chocolate is next to that on the right. The first four buildings are original, the same ones that have been pictured in old photographs of Naperville. Just beyond is the new Washington Place, and in the distance above is Van Buren Place. U.S. Bank, the old Naperville National Bank, is on the right. (Author's collection.)

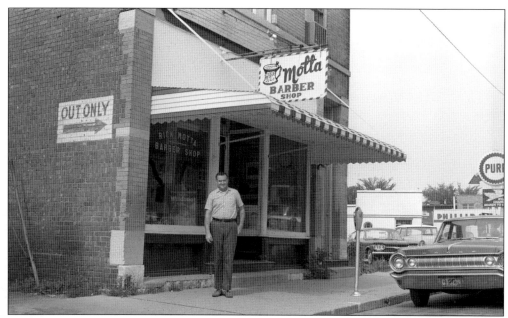

RICK MOTTA. This photograph was taken when barber Rick Motta put the red, white, and blue awning up to beautify downtown Naperville in 1964. He had been cutting hair at 117 South Washington Street since 1961. When his shop was knocked down as part of the new Washington Place development, he moved to 25 South Washington Street. The land upon which his old store sat is now BriZan dress shop. (Courtesy of Kramer Photography.)

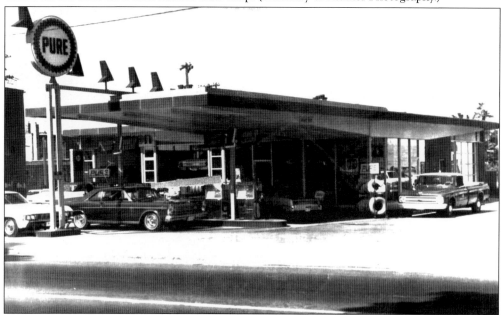

BUZZ'S PURE. When Lee Nelson died in 1961, his son Buzz Nelson took over the gasoline station after graduating from Naperville Community High School. In 1964, the station was torn down and rebuilt, sporting this new look at 103 South Washington Street. It became a Union 76 in 1968. In 1989, Buzz removed the gasoline pumps and rented out the building as a repair shop, which he sold in 2000. (Courtesy of Buzz Nelson.)

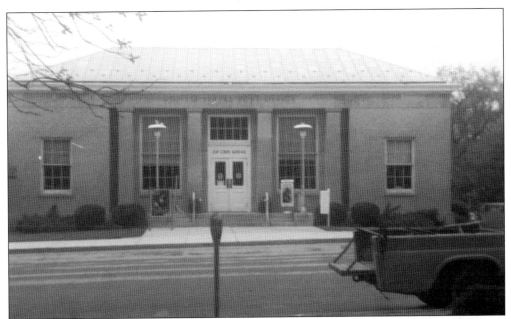

POST OFFICE. The current downtown Naperville Post Office, zip code 60540, has been at 5 South Washington Street at the southwest corner of Benton Avenue since 1940. An addition was constructed in 1966 after this photograph was taken. A second post office was constructed on Ogden Avenue in 1990, and in 1999, a third, small location was opened on Book Road and Ninety-fifth Street in the southwest part of town. (Courtesy of Marilyn Polivka.)

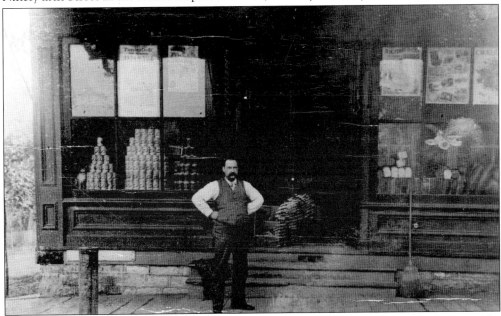

BAPST STORE. Joseph Bapst stands in front of his grocery and bakery around 1875 at the northwest corner of Benton Avenue and Washington Street, where the post office drive-through is downtown. The bakery, where residents bought fresh bread and hot rolls, was in the basement. The building was later a restaurant operated by Paul Steffen. The building was torn down in the 1950s. (Courtesy of Ron Keller.)

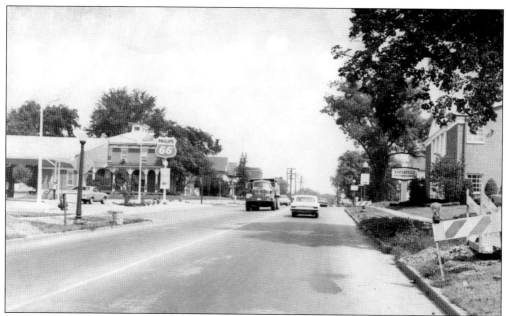

PHILLIPS 66. North Washington Street at Franklin Avenue was the location of the new Phillips 66 run by Vern Brown, who used to work for Ernie at his Phillips station a few blocks to the south. Naperville Savings and Loan is across the street in this 1969 photograph. (Courtesy of Naperville Sun.)

LAW HOUSE. The 1867 historic house at the northeast corner of Washington Street and Franklin Avenue was where former Illinois senator and U.S. congressman Harris W. Fawell organized his law firm Fawell, James and Brooks in 1957. The successor, the law firm of Brooks, Adams and Tarulis, remains there today. (Courtesy of Steve Hyett.)

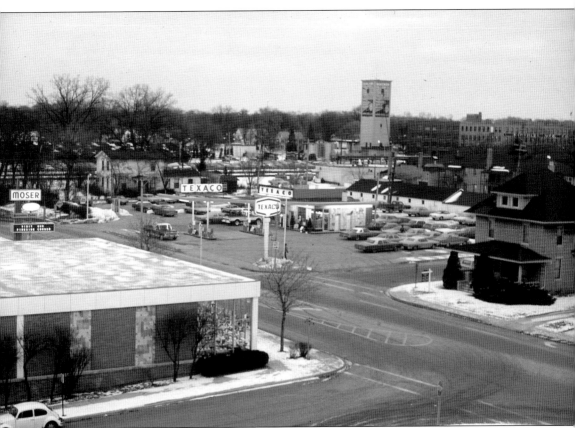

MOSER LUMBER. Harold Moser founded the lumber company at Spring Avenue and Washington Street in 1941 as Moser Fuel and Supply. In 1946, it became Moser Lumber, but with only two builders in town, business was slow. In 1949, Moser bought a small farm and developed 51 lots, and Naperville's growth began. Pictured in the late 1970s, Moser Lumber is across the street from Paul Kueker's Texaco. (Courtesy of Steve Hyett.)

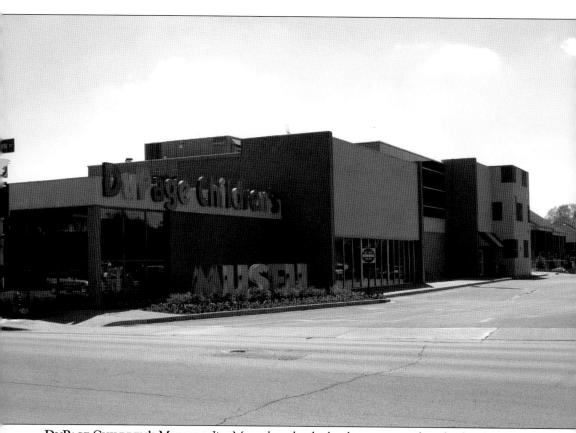

DuPage Children's Museum. Jim Moser bought the lumber company from his brother Harold in 1969, and when Moser Lumber was sold in 1997, he was a major force in bringing the DuPage Children's Museum to his old property, making a major donation toward that end. The DuPage Children's Museum, founded in 1987, moved from Wheaton to the old lumber building in 2001. Moser was also actively involved in the creation of the Riverwalk. (Courtesy of Neil Gates.)

Four

Up-and-Coming Van Buren Avenue

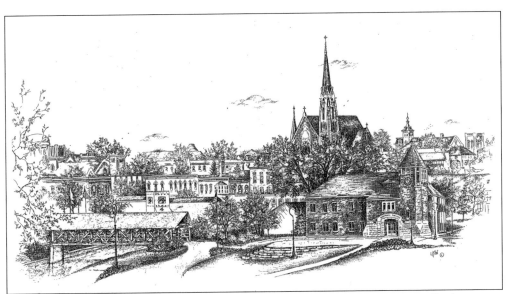

Downtown Overlook. Marianne Lisson Kuhn's drawing depicts many Naperville downtown landmarks such as the covered bridge over the DuPage River, the Naperville Township office, and SS. Peter and Paul Church. (Courtesy of Marianne Lisson Kuhn.)

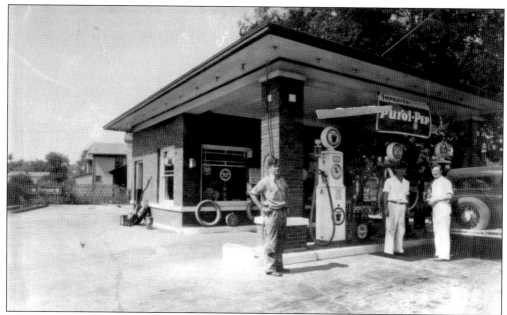

FIRST PURE STATION. The southwest corner of Van Buren Avenue and Washington Street was home to Lee Nelson's Pure Oil station starting in 1935. This was the first station before a remodeling in the mid-1940s. Houses on Van Buren Avenue can been seen behind the station, at a time when that area was residential. Today a Bank of America branch stands at that location as part of the Washington Place development. (Courtesy of Buzz Nelson.)

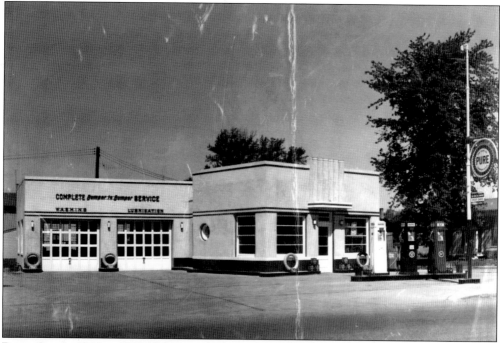

PURE OIL. In 1946 or 1947, Nelson took the canopy off the station and added two garage bays to the building. When Buzz Nelson took over the station after his father's death, he was the youngest Pure Oil owner in the country. (Courtesy of Buzz Nelson.)

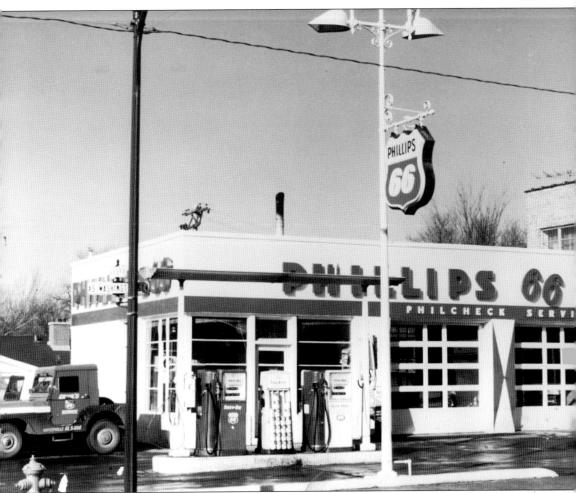

ERNIE'S PHILLIPS 66. Ernest Balstrode's Phillips 66 opened at the northwest corner of Washington Street and Van Buren Avenue in 1939. Everyone called it "Ernie's 66." Not long after Balstrode retired and sold the station to former employee Vern Brown, it was sold to realtor Roy Dudley, who renovated the building and brought his real estate business there. (Courtesy of Marilyn Polivka.)

Catch 35. This is the northwest corner of Van Buren Avenue and Washington Street today, with the Van Buren Place development that was built in 2004. Zano's Salon and Day Spa and Century 21 real estate are upstairs, and Catch 35 restaurant, another of Naperville's "Chicago restaurants" is downstairs. (Courtesy of Kramer Photography.)

Van Buren Garage. Built in 2001, the city's newest parking garage was necessary to handle the increased parking demands of the many new restaurants moving downtown during the first years of the 21st century. The stained-glass front depicts cars through the 20th century. The back of the 530-space garage faces Benton Avenue. The garage had a surface parking lot to the west, which was removed to expand the garage in 2008. The garage addition opened in 2009; stores to fill the retail spaces moved in soon after. (Author's collection.)

OSWALD'S BACK DOOR. This side of Oswald's Pharmacy faced Van Buren Avenue, where the delivery vehicles were parked. William Wickel's son-in-law Louis Oswald took over the store in 1915 and continued until 1954, adding the Rexall franchise to the busy store. In 1954, Oswald's son-in-law Harold Kester took over, enlarged the store three times, removed the soda fountain, and opened Paperback Paradise Bookshop above the store in 1964. (Courtesy of Oswalds Pharmacy.)

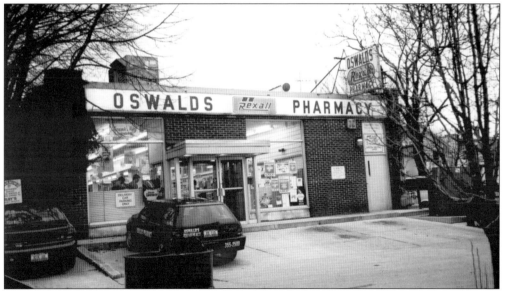

OSWALD'S BACK DOOR, 2004. Kester's son-in-law Bob Anderson bought Oswald's Pharmacy in 1977 and retired in 1991. Not long before the business left downtown and moved to Naper Plaza on Gartner Avenue, this was the pharmacy's back door. Customers entering the back door could quickly get a watch battery changed at the back cash register or buy a greeting card or a picture frame. Oswald's Pharmacy was the last general store in downtown Naperville. (Author's collection.)

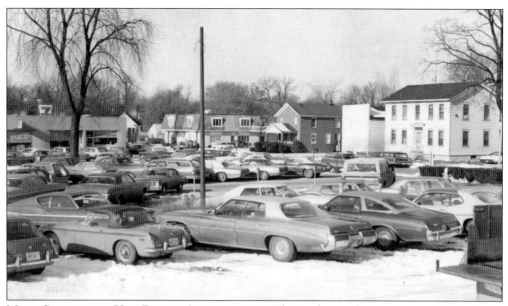

MAIN STREET AND VAN BUREN AVENUE, 1974. This is the southeast corner of Main Street and Van Buren Avenue in December 1974. Ellman's music center is on the far right of the stores lining Main Street in front of the 7-Eleven. The old Beidelman-Kunsch funeral home is across from there at 117 West Van Buren Avenue. Together, a group of businessmen bought the parking lot behind Oswald's Pharmacy in 1958 to provide more off-street parking. (Courtesy of Naperville Sun.)

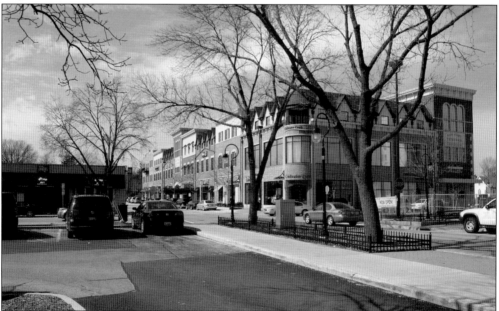

PROMENADE. The parking lot has a different view today, as the northwest corner of Van Buren Avenue has become the Main Street promenade. At the corner is Coldwater Creek clothing on the first level, and their spa above. Hugo's Frog Bar and national retailers occupy the center in 2009. The Naperville Chamber of Commerce offices, among others, are upstairs. Jilly's Piano Bar is at the corner of Main Street, where Ellman's music used to be. (Author's collection.)

Six

NOT REALLY THE MAIN STREET

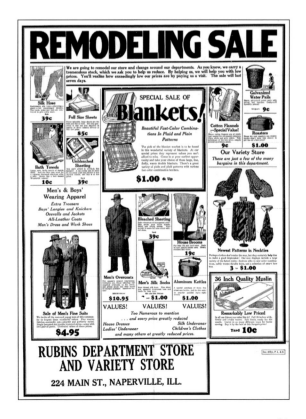

HOME DEPARTMENT STORE ADVERTISEMENT. Check out the prices charged in 1925 by Sam and Anna Rubin's department store and variety store when they occupied 224 South Main Street. Brooms were 19¢, roasters were $1, and three ties cost $1. The Home Department Store opened in 1919 and was in business until 1950. (Courtesy of Steve Rubin.)

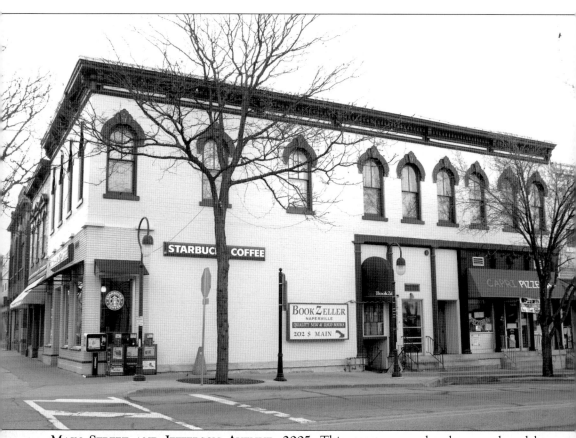

MAIN STREET AND JEFFERSON AVENUE, 2005. This street corner has been anchored by Starbucks Coffee since 1993 when the liquor store was sold. The best-known store to inhabit the lower level of 202 South Main Street, the much-missed Bookzeller, offered used books. Shown in this 2005 photograph, Capri Pizza is next door at 210 South Main Street but only stayed briefly in the space where various eateries have come and gone. (Courtesy of Kramer Photography.)

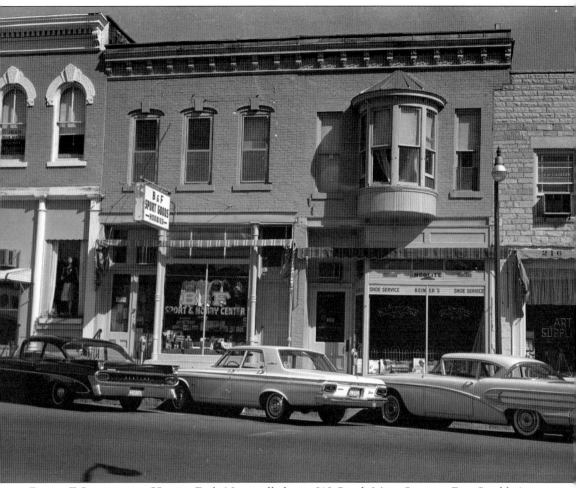

B AND F SPORTS AND HOBBY. Early Naperville knew 212 South Main Street as Dan Strubler's express office and seed business or Neal Marvin's barbershop. But in 1955, this fishing tackle, baseball equipment, and model kit shop opened. Shown in this mid-1950s photograph, next door is Adam Keiner's Shoe Shop in a space that was once Tom Costello's saloon (his family lived upstairs). (Courtesy of Kramer Photography.)

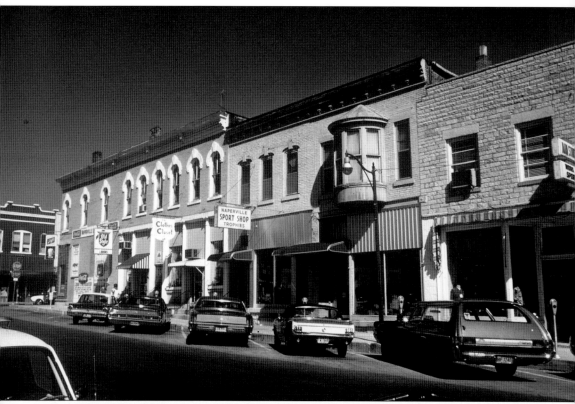

Clothes Closet. This is a late-1970s photograph of the same corner, where the Clothes Closet sign is just above the State Farm sign. Naperville liquors anchors the corner, and the Naperville Sport Shop opened at 212 South Main Street. The shop was the place where a generation of Naperville kids bought their soccer shirts and shoes and letter jackets and equipment, with a dose of good advice from proprietor Ray Gagner, who owned the store from 1976 to 2006. (Courtesy of Steve Hyett.)

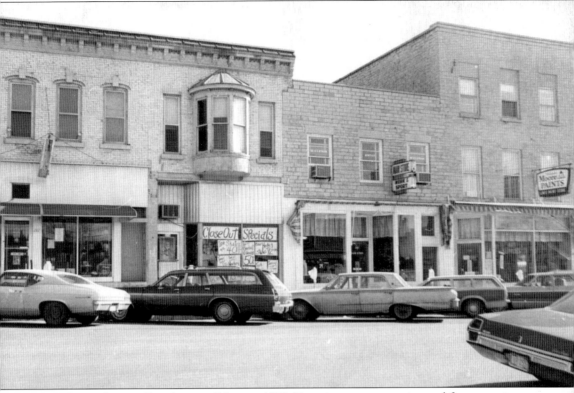

LEWIS PAINT STORE. Seen here in February 1976, Naper's store was a paint and floor coverings shop that had been owned by Norman Lewis since the mid-1940s. The Main Store, Work and Sport opened at 216 South Main Street, and the Naperville Sport Shop was closing out ice-skates and hockey equipment. The Main Store later was home to Cameo Travel and Hoohobbers and, currently, GameStop. (Courtesy of Naperville Sun.)

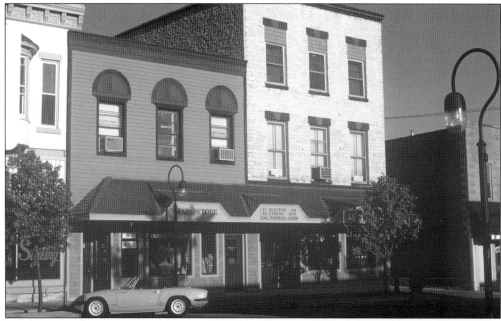

MAIN STORE. After the first redevelopment downtown, not long after the previous photograph was taken, big changes are evident. Storefronts were updated and the Shepherd's Crook lights were installed throughout downtown starting in 1976 as a United States bicentennial project. In this building, the dentist office, optometrist office, and baseball cards shop were upstairs. The Main Store was well known for its selection of Oshkosh B'Gosh clothing for kids. (Courtesy of Steve Hyett.)

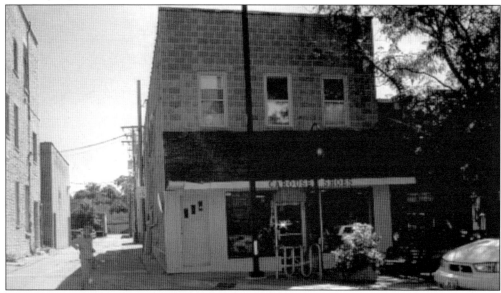

CAROUSEL SHOES. In 2003, Lucille Rubin Cooper Gutman stands next to her one-time home. In the early 1920s, her parents, Sam and Anna Rubin, bought 222 South Main Street and opened the Chicago Bargain Store on the first floor. Their family lived in the four bedroom, one-bath apartment above. The photograph shows Carousel Shoes, a children's shoe store that featured a small carousel inside until 2008. (Courtesy of Norm Rubin.)

SECOND STORE. In 1925, Sam Rubin poses in front of his second store at 224 South Main Street next to the first building he bought on the same street. These were two of many buildings the family owned or developed on Main Street during the following 80 years. This building later became a laundromat and Heaven on Seven restaurant. (Courtesy of Norm Rubin.)

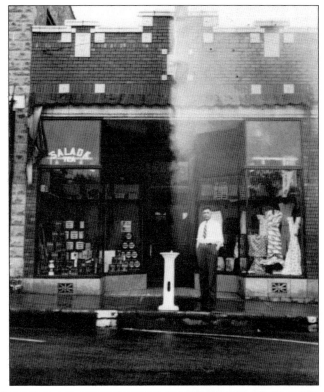

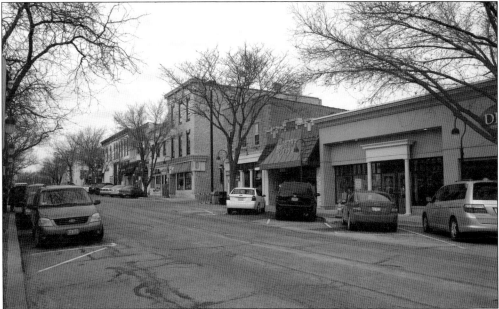

DEAN'S, 2009. Fifty years after Dean's Clothing opened in this location, it sports a new look on the outside. The men's and women's shop was remodeled in 2006, 20 years after Deen DeGeeter's son Greg joined the business. Boys' clothing was dropped in the late 1980s. Heaven on Seven is next door in the old laundromat space, and Reiche Hardware used to be where Dean's parking lot is. (Author's collection.)

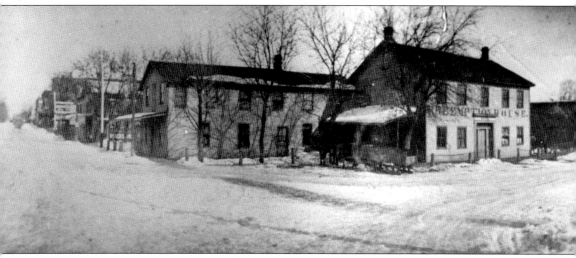

PRE-EMPTION ON MAIN STREET. This view of Pre-Emption House shows how this part of Main Street, looking north, appeared in the late 1800s. Descendents of Sam Hiltenbrand, who owned the tavern from 1893 to 1926, the F. J. Wehrli family raised 13 children there. The Pre-Emption House barn sat to the east where Einstein's Bagels is today and housed horses of guests and those of farmers in town to do business for the day. (Courtesy of Kramer Photography.)

MORGAN CROSSING. This 1980s photograph of the deck on the restaurant at 48 West Chicago Avenue was taken from the parking lot where Walgreen's is today. The parking lot, at Main Street and Aurora Avenue, was home to an IGA store (later Licht's Paint Store) and an A&P grocery. (Courtesy of Steve Hyett.)

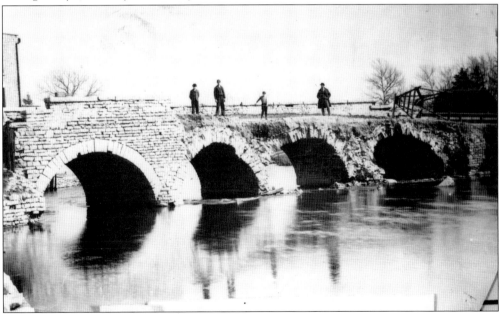

MAIN STREET BRIDGE. Built in 1856 over the DuPage River, its four arches were designed by James Mulvey. The design was not ideal, however, as ice used to get packed into the arches, throwing water over the bridge and damaging property. This 1892 photograph was taken just after the bridge collapsed following 27 days of rain that April. The new bridge had two arches, and it was replaced in 1930 and 1931. (Courtesy of Kramer Photography.)

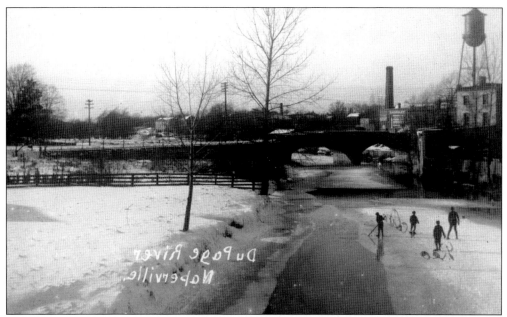

MAIN STREET BRIDGE AND TOWER. This photograph was flipped so the words are backwards, but this was the two-arch replacement bridge over the DuPage River in the late 1800s and early 1900s. The water tower is located approximately where today's Sushi House is near the corner of Webster Street and Jackson Avenue. Just to the right of where the children are playing is today's Rosebud restaurant. (Courtesy of Steve Hyett.)

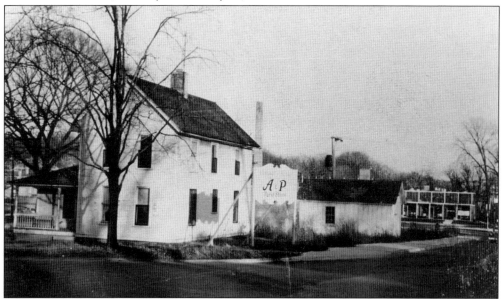

A&P, COMING SOON. At the time of this photograph in the late 1940s or early 1950s, the A&P was down Main Street to the north, where Talbot's is today. The new A&P was built here at the northeast corner of Main Street and Aurora Avenue in the 1950s, where Walgreen's is today. The strip center on Washington Street, which is empty today, can be seen in the background, and where Burger King is today is just out of the photograph on the right. (Courtesy of Naperville Sesquicentennial Photo Album.)

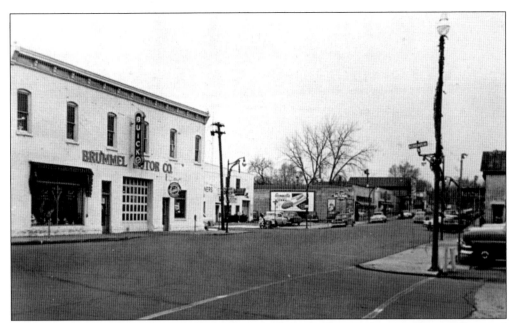

BRUMMEL BUICK, 1955. Main Street looking north from Chicago Avenue featured Brummel Motors where the Riverwalk entrance is today. Brummel's used car lot can almost be seen across the street to the right. On the west side, a National Tea sign can be seen on the wall of the building at 225 South Main Street, where the Gap store is today. (Courtesy of Naperville Sesquicentennial Photo Album.)

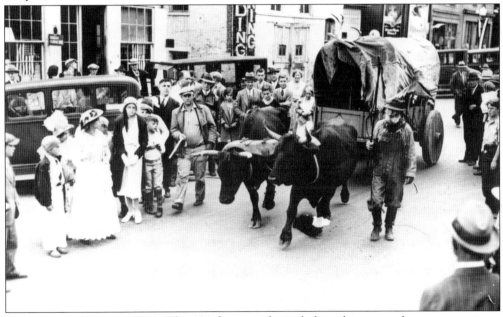

CENTENNIAL PARADE, 1931. The 200-float parade, including this team of oxen portraying a century of Naperville, went down Main Street. The feed store is where the Gap is today, and the Welding store is today's Talbot's. Sam Rubin is in the crowd wearing a tie toward the left side at the rear of the car, and his daughter Lucille is wearing a black coat and hat. Later that day, Mayor Anton Cermak of Chicago spoke at the festivities. (Courtesy of Norm Rubin.)

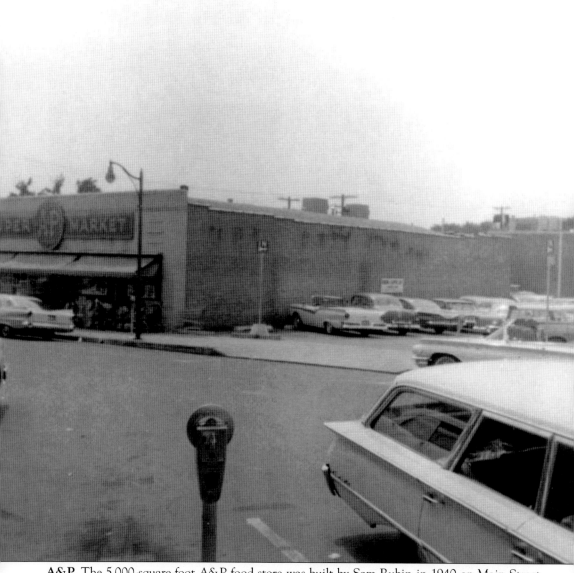

A&P. The 5,000-square-foot A&P food store was built by Sam Rubin in 1940 on Main Street across from his Home Department Store. The A&P later moved south down Main Street to the corner of Aurora Avenue. Rubin built a National Tea store next door in 1947 and then replaced it with a 15,000-square-foot store around the corner in 1960. (Courtesy of Naperville Heritage Society.)

COLONIAL CATERERS. When National Tea moved from this building in 1961 to the new, larger building on Jefferson Avenue, Al Rubin's Colonial Caterers moved in, taking just half the store. The other half was leased to Dutch Main Laundromat. When both tenants moved on, the Rubins leased the store to Expressions furniture and, in the early 1990s, to the Gap and Gap Kids. (Courtesy of Naperville Heritage Society.)

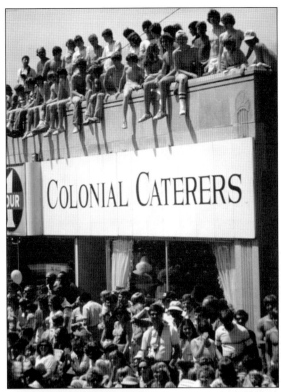

EXPRESSIONS. This is the same part of Main Street in the late 1980s as seen above, where a Naperville police officer chalks tires to keep track of on-street parking. Expressions furniture store was at 225 South Main Street, where a feed store had been until about 1935. Talbot's just recently opened next door in the previous A&P store on the property where Happy Heiss had his blacksmith shop years before. (Courtesy of Steve Hyett.)

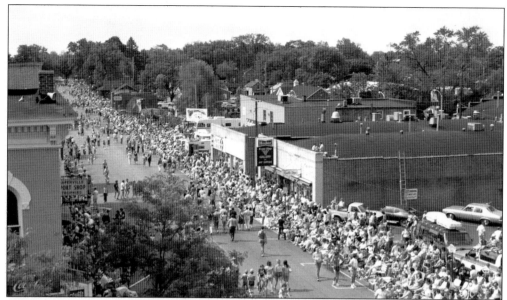

MAIN STREET SESQUICENTENNIAL. The crowds came out to celebrate Naperville's sesquicentennial in 1981, the day after a concert and fireworks, coordinated with a local radio station, took place at Knoch Park on July 4. Main Street at this point features Hooker Frame Shop, Gallery and Art Supplies and a Sears mail-order shop. The Riverwalk flags are up, and DuPage River Animal Hospital on the south bank of the river can been seen. (Courtesy of Kramer Photography.)

TALBOTS, 1996. This photograph shows same location as above 15 years later. Now Talbot's is located on the west side of the street, but the parking lot on the right still belongs to the CeeBees grocery store, although it disappeared about a year after this photograph and became an Eddie Bauer store. (Author's collection.)

KRAMER STUDIO. Just before the Gap and Gap Kids moved in, this 1997 photograph shows Kramer Photography studios and an empty political office. Kramer moved to a new studio on Washington Street just north of Ogden Avenue. (Courtesy of Kramer Photography.)

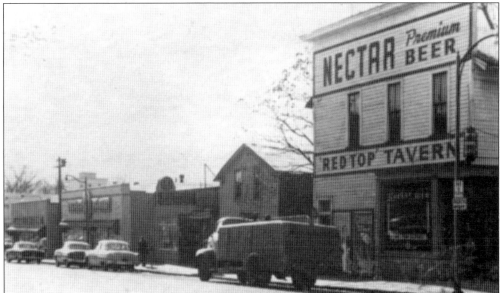

RED TOP. Here is another view of the A&P and National Tea stores on South Main. The two buildings to the right were razed when National Tea moved in 1960. The Red Top Tavern, which closed in the mid-1950s, was formerly called Washington House, a hotel, saloon, and dining room featuring German food that was owned by Jacob Keller. The building was moved to near the Centennial Beach Little League field. The building to the south was Floyd Rosensteil's shoe repair shop. (Courtesy of Naperville Sesquicentennial Photo Album.)

ANDY'S POPCORN STAND. Andy Stoos sold hot, fresh popcorn for 25¢ a bag from his stand on Main Street next to the car dealership. The shack was big enough for a wood-burning stove, two chairs, and a popcorn machine inside. Napervillians often stopped by Andy's before heading to Central Park for band concerts. When he threw old popcorn out the back door, however, he attracted snakes, according to neighbor Lee Sack. (Courtesy of Marilyn Polivka.)

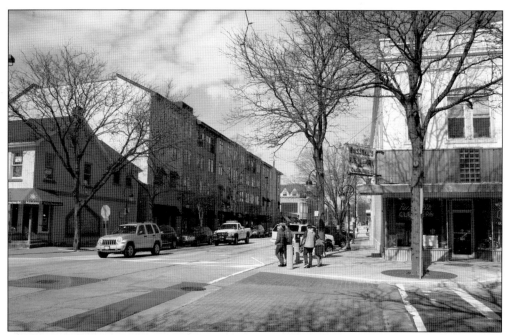

AFTER ANDY. Giordano's Pizza, Peterson's Wines, Moshi Moshi, and Jilly's Piano Bar are now where Andy's was. They comprise the first floor of the NaperPlace on Main development, built in 2005. Russell's is still where it has been for so many years and looks pretty much the same. The Hozhoni Gallery is in the old Fidler's building at the corner. (Author's collection.)

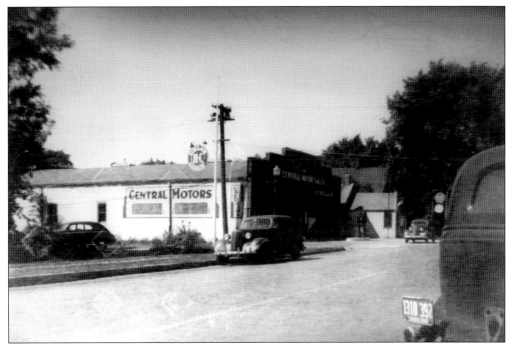

CENTRAL MOTORS. Sometime before the 1950s, Central Motors occupied the land just south of Van Buren Avenue on Main Street. It later became Bell Motors and Lee Sack Dodge/Rambler. (Courtesy of Clay Netzley.)

LEE SACK RAMBLER. Lee Sack bought the Dodge dealership at 119 South Main Street from Jim Belandi in 1955. Sack remembers putting up the Rambler sign in 1958. In 1963, he sold the dealership to Bob Koller, who later moved it to Washington Street near Ogden, where Harris Bank is today. This photograph was taken from the parking lot behind Oswald's Pharmacy's back door, commemorating its new delivery car. (Courtesy of Oswald's Pharmacy.)

TASTY BAKERY. Taken from Jefferson Avenue looking north on Main Street towards Van Buren Avenue, this was Tasty Bakery's new location after it left Jefferson Avenue in 1979. Tasty Bakery's building had been the Koller Dodge office. Down the street is Ellman's music store at the corner. (Courtesy of CVG.)

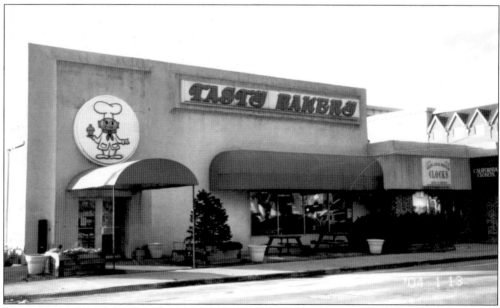

TASTY BAKERY, 2004. This photograph was taken not long before the building was torn down to make way for a housing development with stores on the first floor. Elgin Clocks and then California Closets are next door. The housing development was supposed to be marketed for seniors, but it ended up being rented out to North Central College students. (Author's collection.)

Seven
THAT ODD, SHORT, ONE-WAY JACKSON AVENUE

CELEBRATION, 2000. This sign sat outside the Alfred Rubin Community Center during the last weeks of 1999. On December 31, 1999, the city of Naperville held a huge New Year's Eve party on the streets of downtown and in several buildings and restaurants. The night began with a residents' torchlight march of the centuries from Naperville Central High School to downtown and ended with a ball drop lighting up the year 2000. (Author's collection.)

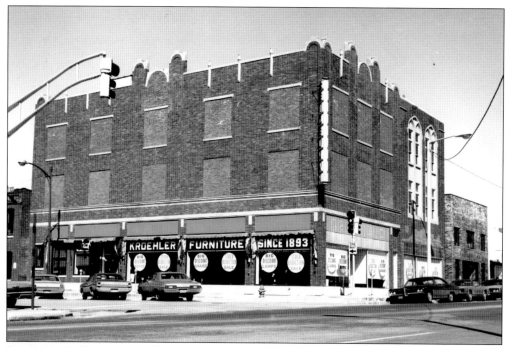

BEIDLEMAN'S FURNITURE. Built in the center of Naperville in 1893, Beidleman's anchors the corner of Jackson Avenue and Washington Street. This is how it looked in the 1970s, not any different than the building looks today. The building on the right has distinctive windows that are indeed indicative of a chapel. It was common for furniture businesses in those days to build caskets and have undertakers and chapels. (Courtesy of Lana Heitmanek.)

BEV PATTERSON PIANOS AND ORGANS. Under construction in 1970, Bev Patterson Frier built her business at the southwest corner of Jackson Avenue and Washington Street, where Charlie Burgess's Standard Oil gasoline station had been. Eventually the place was turned into a restaurant; today it is Jimmy's Grill. Across Jackson Avenue west of Beidleman's building, a corner of the Naperville Sun building can be seen as well as Beidleman's old workroom, later turned into restaurants. (Courtesy of Bev Patterson Frier.)

THE NAPERVILLE SUN. Founded in 1935 by Harold Moser, the paper was sold just a year later to Harold and Eva White and operated in offices on Washington Street. In 1965, the paper moved to 9 West Jackson Avenue, where it anchored the block until Copley Press decided to move the office to Ogden Avenue in 1998. The following year, the remodeled building reopened as a Pottery Barn and Williams-Sonoma. (Courtesy of Downtown Naperville Alliance.)

POTTERY BARN, 2009. This is the north side of Jackson Avenue from the site of the historic Pre-Emption House. The Naperville Sun to Pottery Barn conversion forced the Century Walk to relocate its first mural of the 130-year history of newspaper publishing in Naperville, originally on the west side of the building. With $15,000 from Copley Press, the 1996 mural was moved to the north wall of what was then Ellman's music at Main Street and Van Buren Avenue. (Author's collection.)

RIVER'S EDGE. The northwest corner of Jackson Avenue and Main Street was home to Baker Exchange in the mid-1980s when this photograph was taken. Russell Martin and Son moved in later, and in 2002, it became home to Country Curtains. Dean's Clothing is on the right across Main Street. In 1896, John Zaininger's coal business consisted of a small office and a scale at this location; the coal was piled in back along Jackson Avenue. (Courtesy of CVG.)

BEFORE RIVERWALK. This is a view of the DuPage River along West Jackson Avenue just west of Main Street before Naperville's Riverwalk. The blue building in the background still is home to Henczel's barbershop, as it was at the time of this pre-1981 photograph, and the westernmost doorway was the entryway to Arbor Vitae juices for many years. In 2009, Red Mango authentic frozen yogurt moved in. (Courtesy of Downtown Naperville Alliance.)

RIVERWALK LOT. The southwest corner of Jackson Avenue and Main Street is still a parking lot but looks much different today with the Riverwalk and the repainted cream and green building that used to be light blue. Looking from Rosebud's front door on Chicago Avenue, the pre-1991 municipal center (where the electric company used to be) that now houses the Canterbury Shop and Egg Harbor can be seen in the distance to the left. (Author's collection.)

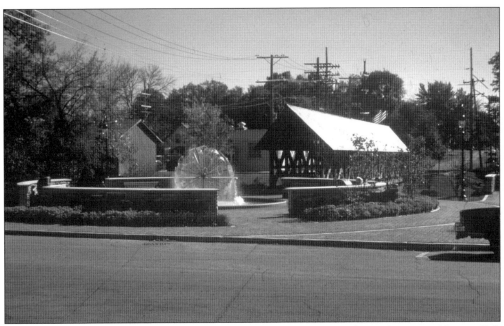

THE DANDELION FOUNTAIN. Where Webster Street runs into Jackson Avenue is Naperville's beloved Dandelion Fountain and footbridge over the river, seen here before the power lines were buried and before the new Naperville Township office was built on Water Street. The trees surrounding the fountain are Japanese lilacs. (Courtesy of Steve Hyett.)

RIVERWALK FLAGS. The first Riverwalk flags fly over the southeast corner of Jackson Avenue and Eagle Street. At the northwest corner of intersection, a stone brewery once sat, which later was used as storage of aging beer for John Stenger's Naperville Brewery, located on Franklin Avenue. Naperville's municipal center was built here in 1966, and in 1996, it became a shopping and restaurant complex, home of Egg Harbor, the Canterbury Shoppe, and Sushi House. (Courtesy of Steve Hyett.)

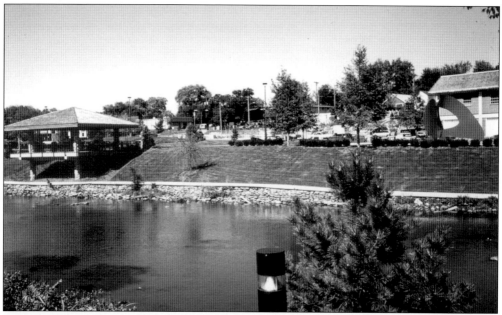

PAVILION. This is the southwest corner of Jackson Avenue and Eagle Street in the 1980s, where Naperville's distinctive red sculpture, created by Jack Arnold of Glen Ellyn and dedicated in 1984, holds court. Across Jackson Avenue, the Riverwalk community center is seen in the background before it was remodeled in the 1990s and renamed the Alfred Rubin Community Center. (Courtesy of Downtown Naperville Alliance.)

NO BOOKS YET. Here is the house on the future site of the new Nichols Library. Some houses that were there were moved off the property, including one now on Jefferson Avenue that has a well-known statute of a boar in the front yard. Another was moved all the way south to (appropriately enough) Book Road and 119th Street. (Courtesy of Marilyn Polivka.)

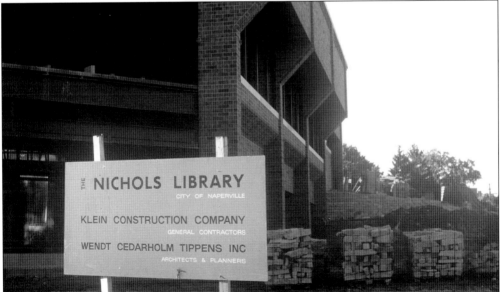

NICHOLS CONSTRUCTION, 1986. Nichols Library moved to land surrounded by Jackson Avenue, Webster Street, Eagle Street, and Jefferson Avenue shortly after this photograph was taken of the northwest corner of Jackson Avenue and Webster Street. At the time, it was Naperville's only library. New branches have been built on Naper Boulevard and Ninety-fifth Street. In 2009, the Naperville Public Library was ranked No. 1 out of 9,000 in the country for an unprecedented ninth year in a row by the American Library Association. (Courtesy of Steve Hyett.)

TAVERN BY THE BEACH. The beloved Beach Inn at the northwest corner of Jackson Avenue and Ewing Street was owned by Annie "Ma" Kunzer from 1933 when she was 53 and continuing after her husband, George, died in 1940. The old tavern opened before liquor licenses existed, so it was grandfathered in and never had one. The building's floors were uneven, and the walls seemed to be caving in, but the bar continued until the early 1990s thanks to Kunzer's daughter Georgia. (Courtesy of Marilyn Polivka.)

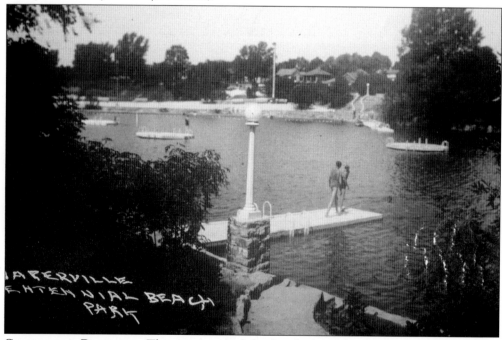

CENTENNIAL PLATFORM. This is a view of the beach from the northeast corner looking southwest, highlighting the many platforms floating in the deep waters of Centennial Beach. Local residents swam there for free in the early years. Visitors had to pay a fee, which was a great source of income for the city beginning in the Depression and for long afterward. Plans to renovate Centennial Beach's limestone bathhouse, seen in the distance, are in the works for 2009. (Courtesy of Steve Hyett.)

Eight
CHICAGO AVENUE, OR WATER STREET

NAPERVILLE TROLLEY. Nothing about 21st-century downtown Naperville would be complete without mentioning the Naperville Trolley, which has been run by Don Wehrli since 1995 after a trip to Washington State where he took a trolley tour. The 67-year-old retiree bought the yellow trolley and began another Naperville tradition. Today Naperville Trolley and Tours has four trolleys that conduct tours and are rented for special events. Their slogan is, "It's always *more* fun on the Naperville Trolley! Ding! Ding!" (Courtesy of Stephanie Penick.)

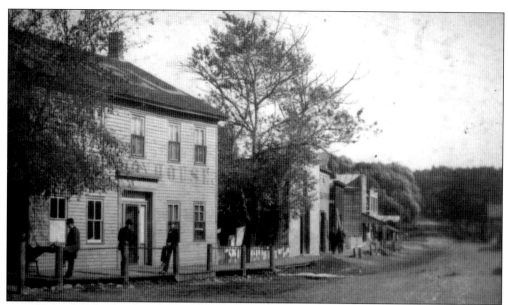

PRE-EMPTION HOUSE. The Pre-Emption House was built in 1834 where Sullivan's steakhouse is today. This view looks east on Chicago Avenue. The Pre-Emption House was the first hotel and tavern west of Chicago, named for the Pre-Emption Act, which allowed settlers to claim land at $1.25 an acre. The building, where some say Abraham Lincoln once gave an impromptu speech from the roof, was torn down in 1946 and replaced by an expansion of the Cromer Motors Company. (Courtesy of Kramer Photography.)

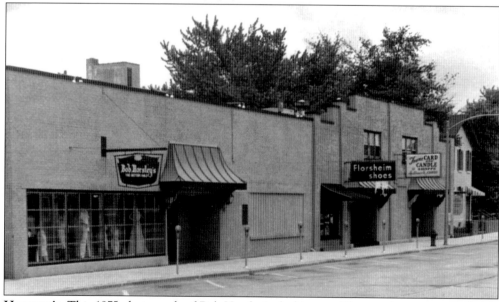

HORSLEY'S. This 1975 photograph of Bob Horsley's clothiers on Chicago Avenue is now home to Einstein Bagels. The three shops pictured are housed in what once was the Cromer Motors building, remodeled in 1968. Horsley's closed in 1998, and its parking lot is where Sullivan's steakhouse was built. The Florsheim shoe store later became the Footery in 1979, Pam's Sportswear from 1984 to 1993, Legends of London Doc Martens, and Campus Colors. (Courtesy of Naperville Sun.)

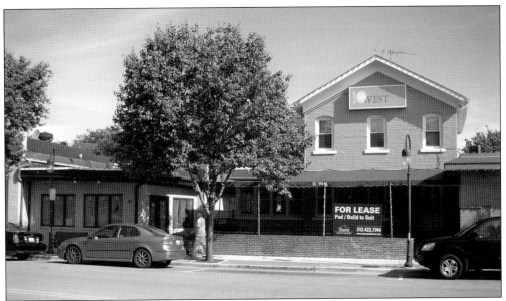

MILLER HOUSE, 2009. In 2009, just before it was demolished, Milly Miller's house at 19 West Chicago Avenue anchored the lot between two streets. It was built in 1869 by a wagon wheel manufacturer. The address of the other side of the house was 10 West Jackson Avenue. In recent times, Miller's house was home to Pizza Et Cetera in 1979, David's French Country Bistro, Sweet Basil (closed 1997), Elaine's (2001), and 10 West (closed in 2006). (Courtesy of Jerry Goldstone.)

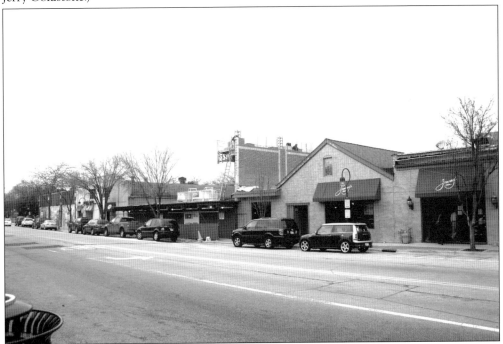

MILLER HOUSE CONSTRUCTION. Just a few weeks later, the walls of a new two-story building rise where Miller House stood for so many years. Charles Schwab and Company will move into the new building, just west of Jimmy's Grill, owned by Jimmy Bergeron. (Author's collection.)

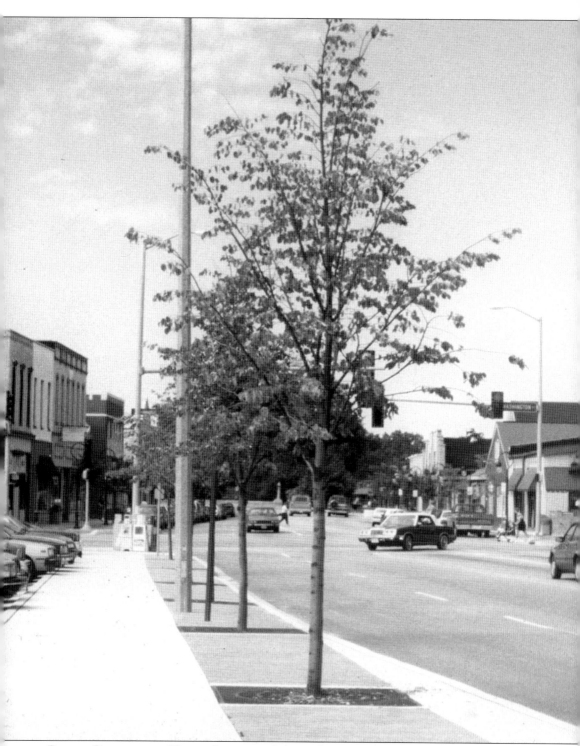

BEFORE BARNES AND NOBLE. Just west of the parking garage on East Chicago Avenue, the building on the right housed Graham Crackers Comics. Beyond that, the Landmark Restaurant is visible on Washington Street between Chicago and Jackson Avenues. To the left in this

late-1990s photograph, taken before Barnes and Noble loomed over the northeast corner of this intersection, is River Square, a small shopping center that sits on land occupied for years by Netzley's garage. (Courtesy of Steve Hyett.)

DEER ON CHICAGO AVENUE. The cars (with their unusual loads) are traveling east on Chicago Avenue in front of what later became Graham Crackers Comics and the Tong Inn, as seen from Netzley's garage. Frank S. Goetsch and Anthony Kochly's blacksmith shop was at that corner in the 1890s. In the early 1900s, the original frame building was moved to the back of the property, and the brick building went up, remaining as the same company for more than half a century. (Courtesy of Clay Netzley.)

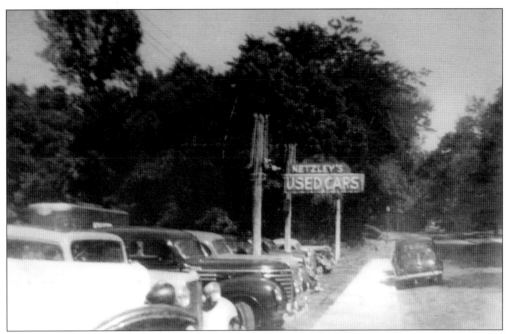

NETZLEY'S USED CARS. Clay Netzley did not believe the stories he heard about the old-time medicine man who used to park in this lot and toss empty medicine bottles on the ground. But when Netzley's began trenching in the empty lot to bring electricity to it for the used car business, construction workers found the old medicine bottles. (Courtesy of Clay Netzley.)

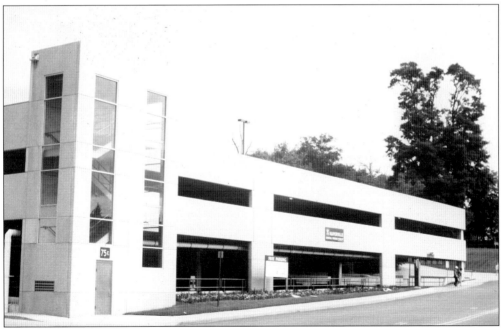

PARKING GARAGE. This is Naperville's first parking garage when it was built in 1987. The 553-space central parking facility is located on Chicago Avenue east of Washington Street and is also accessible off East Jefferson Avenue. It was financed one-third by the city and two-thirds by downtown property owners. (Courtesy of Steve Hyett.)

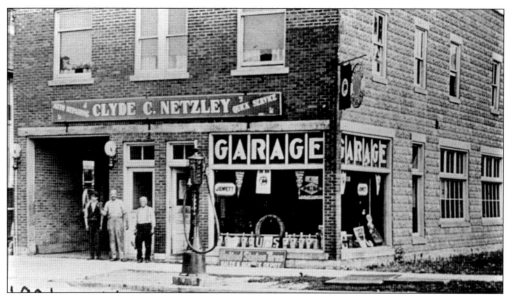

NETZLEY'S GARAGE, 1921. Old Napervillians remember the southeast corner of Chicago Avenue and Washington Street to be Clyde C. Netzley's garage, as seen here. In 1923, the mechanic began selling cars, and in 1926, he became a Chrysler dealership. This corner was Netzley Chrysler/Plymouth until it was torn down in 1987 to make way for the River Square shopping center. The used car lot sat across Chicago Avenue where the city parking garage is now. (Courtesy of Naperville Sesquicentennial Photo Album.)

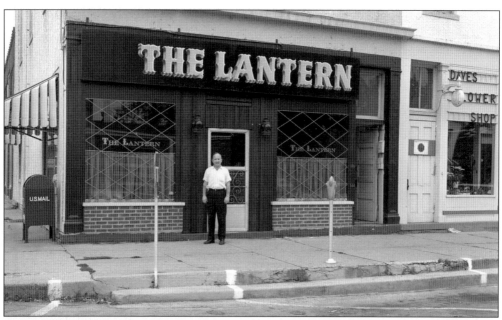

THE LANTERN. It was the Rainbow Café in 1948, but since 1966, the Lantern has occupied the southwest corner of Washington Street. Pat and Don Feldott owned the bar and restaurant until their son David took over in the late 1990s. In 1998, "A City in Transit" was painted on the east wall of the Lantern, as a part of Naperville's Century Walk public art project. Dave's Flower Shop was next door in this pre-1976 photograph. (Courtesy of Kramer Photography.)

FEATURES. This 2009 photograph of the south side of West Chicago Avenue shows Rosebud on the west and part of the Lantern on the east. Features had recently remodeled and expanded, and Frankie's Blue Room is atop the building. The Rosebud building was owned by Prince Castle in the 1940s, where it manufactured a base for its ice cream as well as the Prince Castle English Toffee and roasted nuts. (Author's collection.)

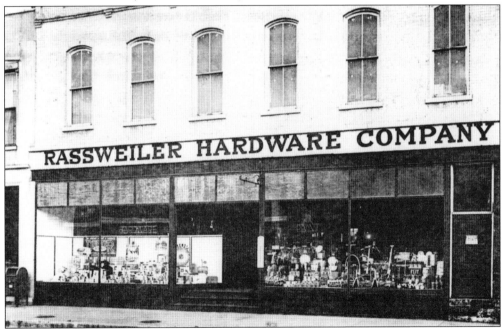

HARDWARE, 1948. In the late 1800s, Hillegas Hardware was at 22 West Chicago Avenue, and before 1920, it became Rassweiler Hardware. The Buikemas bought the business in 1948 and now operate nine Buikema Ace Hardware stores throughout the western suburbs, including one north of downtown on Washington Street. (Courtesy of Kyle Buikema.)

BEFORE COOKIE DOUGH. The old hardware store at 22 West Chicago Avenue was split into two stores at the time of this photograph. This structure was made of three frame buildings, which were encased in brick and remodeled to become the Naperville Hotel in 1928. In 1994, it became the home of Jim Bewersdorf's Cookie Dough Creations. (Courtesy of Charles Vincent George.)

Rosebud. On the left is the building that used to be Crockery Hardware, one of Naperville's oldest store buildings. On the right is Rosebud restaurant, opened in 1997, which had been Peck's Hickory Barbeque and, beginning in 1983, Morgan's Crossing Tavern. That restaurant was named for Morgan Paine, a captain in the Blackhawk War in 1832 who built Fort Paine a few blocks away. The building was once the Naperville Steam Laundry, the community's first commercial laundry. (Courtesy of Kramer Photography.)

www.arcadiapublishing.com

Discover books about the town where you grew up, the cities where your friends and families live, the town where your parents met, or even that retirement spot you've been dreaming about. Our Web site provides history lovers with exclusive deals, advanced notification about new titles, e-mail alerts of author events, and much more.

Arcadia Publishing, the leading local history publisher in the United States, is committed to making history accessible and meaningful through publishing books that celebrate and preserve the heritage of America's people and places. Consistent with our mission to preserve history on a local level, this book was printed in South Carolina on American-made paper and manufactured entirely in the United States.

This book carries the accredited Forest Stewardship Council (FSC) label and is printed on 100 percent FSC-certified paper. Products carrying the FSC label are independently certified to assure consumers that they come from forests that are managed to meet the social, economic, and ecological needs of present and future generations.

Mixed Sources
Product group from well-managed forests and other controlled sources

Cert no. SW-COC-001530
www.fsc.org
© 1996 Forest Stewardship Council

Find Your Place in History.